# BUILDIN
# OF LONDON

*Roger Fitzgerald*

## ROGER FITZGERALD

Artifice
books on architecture

*To Lynne, James and Will*

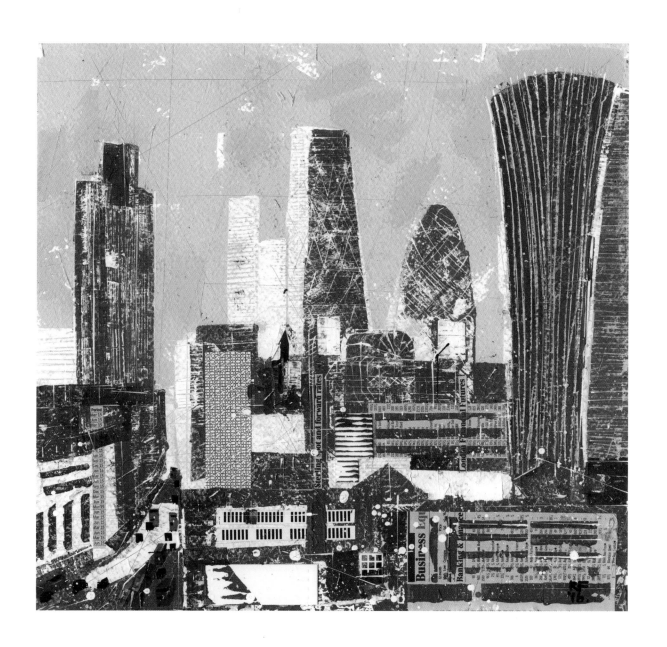

# CONTENTS

# INTRODUCTION

London is an extraordinary place. One of the great capitals of the world, the buildings and external spaces play a vital role in making it special.

Quality and character are often found in unexpected places, and this book is as much about the functional working buildings of the capital—warehouses, stations, markets and alleyways—as it is about the better-known grand set-pieces: the palaces, cathedrals and civic squares.

This is therefore an eclectic collection of my favourite places in London, capturing their unique qualities through paintings and words. They are the product of having worked as an architect, lived, commuted, shopped and been entertained in the capital, and by turns delighted, frustrated and thrilled in the process.

There are more academic tomes on London's buildings than this, and more all-encompassing guidebooks. My aims are more modest and more personal: to capture what matters to me. If the result makes you pause, to consider whether you think I have captured the essence of a place through the flick of a paintbrush or the twist of a word and look more closely at what is all around you, then I will be content. With mobile phones close at hand, we are obsessed with photographing or filming places and events, instead of looking closely and enjoying experiencing them.

The buildings—and, just as importantly, the spaces between them—contribute enormously to our experience of the capital. From the frivolous and ornate to the stark and modern; buildings for show and grandeur to the workman-like and functional; places teeming with humanity to the tranquil and secluded, London offers something for all tastes and needs.

Like most architects I like structure. The buildings have therefore been organised into categories. I have tried to capture the spirit of buildings, and the essence of London as a whole, rather than deal with the minutiae. My painting technique has evolved over the year or so spent preparing this book, with growing interest in collage, texture and pattern, but retaining a love of lines and the depth of black ink.

And what of London? I have come to realise how much London is changing: wealthier, more cosmopolitan, more continental. The relationship between old and new is becoming more distinct: a sharper contrast enhancing both. Forgotten and run-down areas—Shoreditch, Spitalfields, Bermondsey—are the new fashionable places, and the better for the inward investment. This comes at a cost, with Soho (for example) once gloriously controversial and illicit, now wealthy and respectable ever more like its neighbour, Mayfair.

Therein lies the greatest threat to this vibrant, teeming, lively city. It needs contrast. Differences and contrariness have helped to create the places where the Huguenots, fleeing persecution, could settle; the bars where Francis Bacon could drink; the juxtaposition of railway viaducts with the rooftops of listed buildings; the vitality of real markets. If it all becomes too sanitised, too touristy, too bland, too wealthy, it will lose the gutsy, edgy qualities and contrasts that made it exceptional in the first place.

# ORIGINS AND GROWTH

Before the Roman invasion there had been no major settlement where London is now located. The Romans came to rule the country from Colchester but appreciated the importance of controlling the crossing point of a major river, good for trade. They built a bridge, developed a port, and erected a defensive stone wall around a settlement located where the City now stands, between 190 and 225 AD. Londinium, as they called it, was born.

By the time of the next major invasion, this time by the Normans in 1066, London had grown to become the largest town in England, and William the Conqueror reached the same conclusion the Romans had: London had real strategic importance. The density of development grew within the city walls, and spread gradually beyond them. This dispersion had already been instigated by Edward the Confessor relocating his court to the west, to Westminster. The consequential separation of government and the seat of royalty to the west, from the beating heart of commerce in the City, remains today.

Shortly after midnight on Sunday 2 September 1666 the single most significant event in the history of London occurred: the Great Fire of London. Fanned by a strong easterly wind, the fire consumed most of the original walled city. Yet, in spite of grand plans, and some widening of streets, the narrow winding street pattern was retained, representing the original dense, informal and organic pattern of development. Similarly after bombing in the Second World War, buildings adhered to the original urban pattern.

As London has grown, what were once separate villages have been absorbed. This has happened naturally, without any overriding plan. Compared with villages on the continent — often tightly packed behind defensive walls — the villages themselves were open and loosely defined; often a group of buildings including a coaching inn and church, gathered around a road intersection, sited there for trade and communications.

In London, the term "village" is now used more generally to apply to dense urban locations, such as Marylebone, Notting Hill and Kensington, implying a sense of community gathered around their "High Streets". This also applies to more suburban settings like Clapham, or Ealing: using the word and its connotations is a way for the individual to de-scale the vastness of a city with a population heading inexorably towards ten million.

The Victorian era was London's greatest period of change and expansion. Until then, London's footprint corresponded to the original Roman city, Westminster and Southwark beyond the walled confines, and Georgian expansion to the west; further afield were separate villages. From the 1820s, industrialisation and then later the railways brought rapid growth, row upon row of terraced housing filling the farmland that previously separated settlements.

London grew and relied increasingly on the means by which people were transported to, from and around the capital. Underground and suburban railway stations, and the main railway termini were built and became the focus of people's lives on a daily basis, attracting shops, cafes, pubs, hotels and offices.

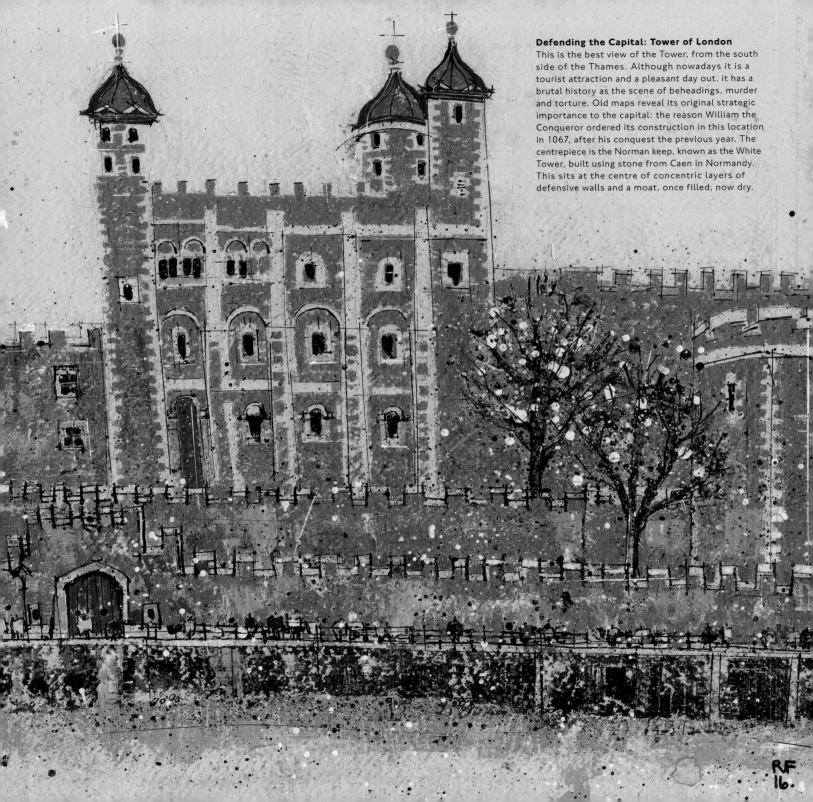

**Defending the Capital: Tower of London**
This is the best view of the Tower, from the south side of the Thames. Although nowadays it is a tourist attraction and a pleasant day out, it has a brutal history as the scene of beheadings, murder and torture. Old maps reveal its original strategic importance to the capital: the reason William the Conqueror ordered its construction in this location in 1067, after his conquest the previous year. The centrepiece is the Norman keep, known as the White Tower, built using stone from Caen in Normandy. This sits at the centre of concentric layers of defensive walls and a moat, once filled, now dry.

RF
16.

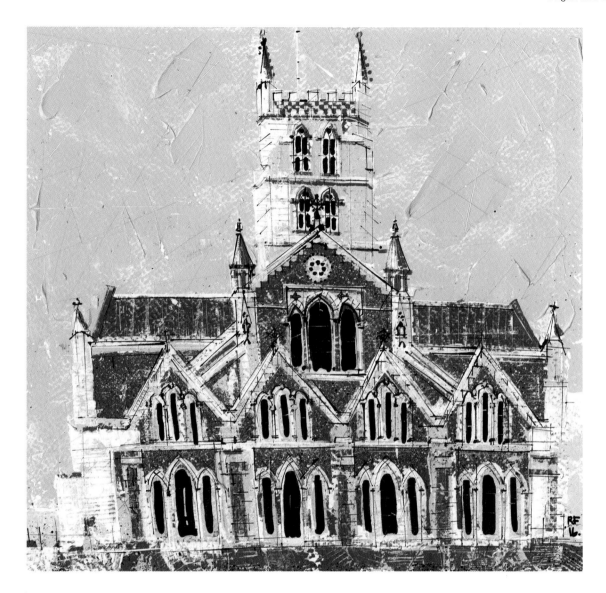

**Settlement on the South Bank: Southwark**

Soon, Londoners started to settle on the south bank outside the original Roman city, in Southwark, or, The Borough. The old London Bridge, completed in 1209, connected it to the main settlement on the north bank.

Being outside the control of the City of London, this was the place for debauchery and lawless pursuits, a warren of inns, prisons, markets, overcrowded houses, yards and alleyways. Only in recent years with the Shard and other developments has the commercial potential of this land, so close to the City, been exploited.

There was a priory here in the twelfth century, but the cathedral was not established until 1905; its urban context, surrounded by roads, a railway viaduct and Borough Market, makes it a relatively low-key and unpretentious cathedral.

### The River and Trade

Until towards the end of the eighteenth century, ships simply moored on the banks of the Thames. As trade flourished and ships became larger, a change of scale was needed, with large wet docks constructed with warehouses alongside, for storage and customs administration. Once a hive of activity, many of its robust, functional buildings have been lost or converted and the docks infilled. At Wapping and Rotherhithe you can still see buildings built right up to the river, with narrow alleyways leading to the very edge of the water.

The river is so wide here (300 metres) that there is no sense of enclosure or place, and it is difficult to find a vantage point from which to enjoy the river facades. It is ironic that, not just here but everywhere, London owes its very being to the river, yet it turns away from it, regarding it as a back not a front.

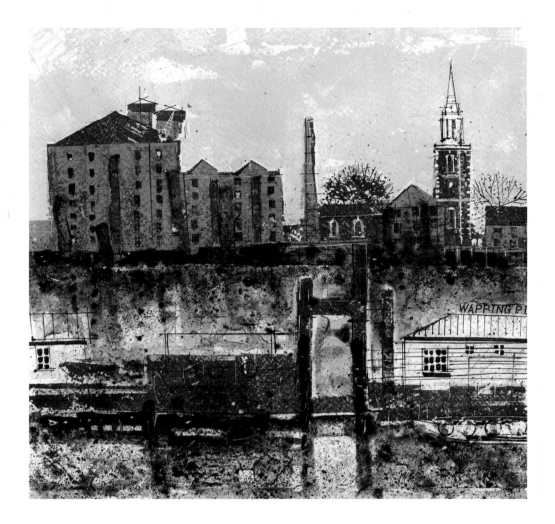

### Bridges across the Thames: Tower Bridge

The oldest crossing was a short distance upstream at the site of London Bridge, but now the flamboyant Tower Bridge is London's most iconic bridge.

It was the result of a long selection process: in 1876 a public competition attracted over 50 entries but only in 1884 was the solution of the City of London Architect, Horace Jones, chosen.

The high-level walkways have a function, to allow pedestrians to cross when the road is raised. Clad in Portland stone and Cornish granite, the building belies its load-bearing stony demeanour, and is actually steel-framed. The two road segments rise to an angle of 86 degrees in around one minute, powered by oil and electricity, formerly by steam.

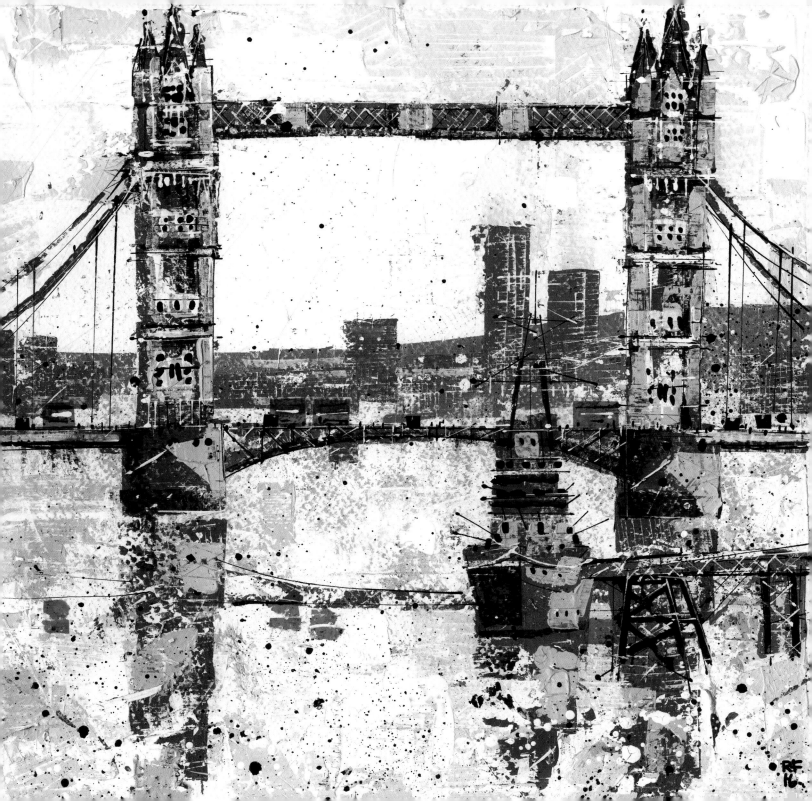

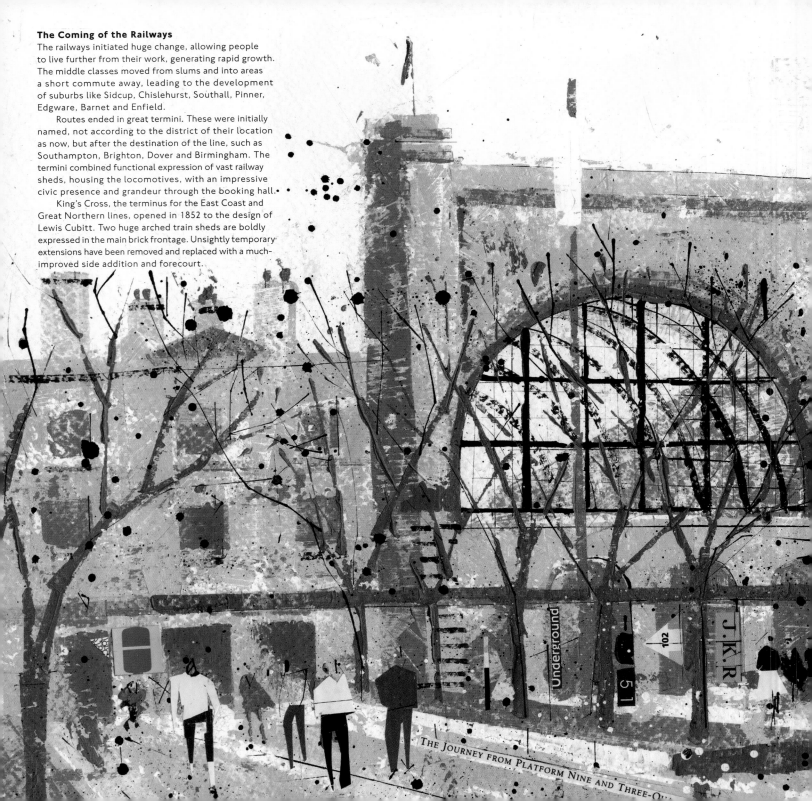

### The Coming of the Railways

The railways initiated huge change, allowing people to live further from their work, generating rapid growth. The middle classes moved from slums and into areas a short commute away, leading to the development of suburbs like Sidcup, Chislehurst, Southall, Pinner, Edgware, Barnet and Enfield.

Routes ended in great termini. These were initially named, not according to the district of their location as now, but after the destination of the line, such as Southampton, Brighton, Dover and Birmingham. The termini combined functional expression of vast railway sheds, housing the locomotives, with an impressive civic presence and grandeur through the booking hall.

King's Cross, the terminus for the East Coast and Great Northern lines, opened in 1852 to the design of Lewis Cubitt. Two huge arched train sheds are boldly expressed in the main brick frontage. Unsightly temporary extensions have been removed and replaced with a much-improved side addition and forecourt.

Underground

J.K.R

51

102

THE JOURNEY FROM PLATFORM NINE AND THREE-QU

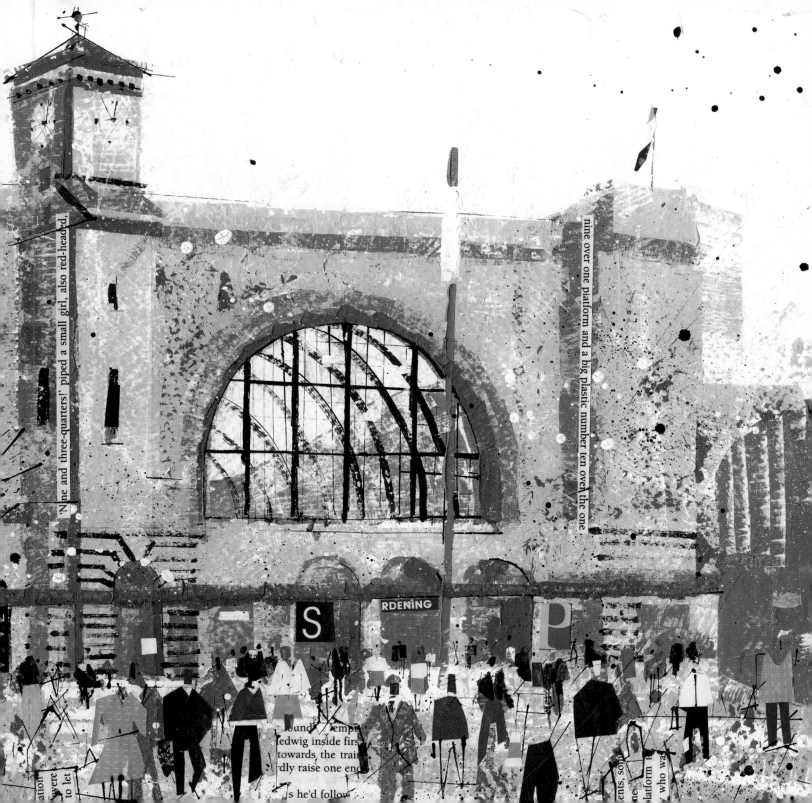

**Connecting London: the Underground**

Essential for getting across the capital ever since its introduction in 1863, as a short track linking Paddington and Farringdon. Today there are 270 stations, 11 lines and some four million passenger journeys every day.

London Underground has been an inspired patron of good design. This book uses the distinctive sans serif design developed by Edward Johnston for the London Underground; the abstract plan designed by Harry Beck in 1933 is an exemplary graphic which reduces a complex map into an easily understood diagram; the Jubilee line extension stations were developed by a selection of Britain's most talented architects. But it is the 1930s buildings by Charles Holden that are the best architectural expression of the golden age of the London Underground: stations such as Park Royal and Arnos Grove.

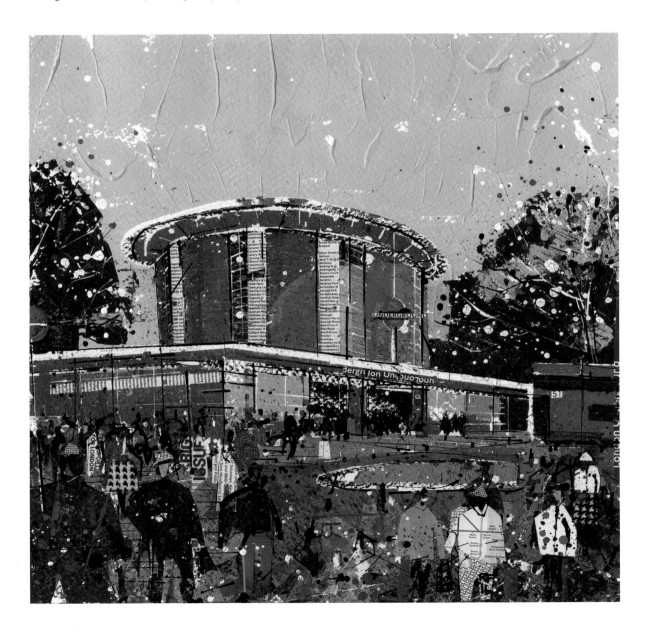

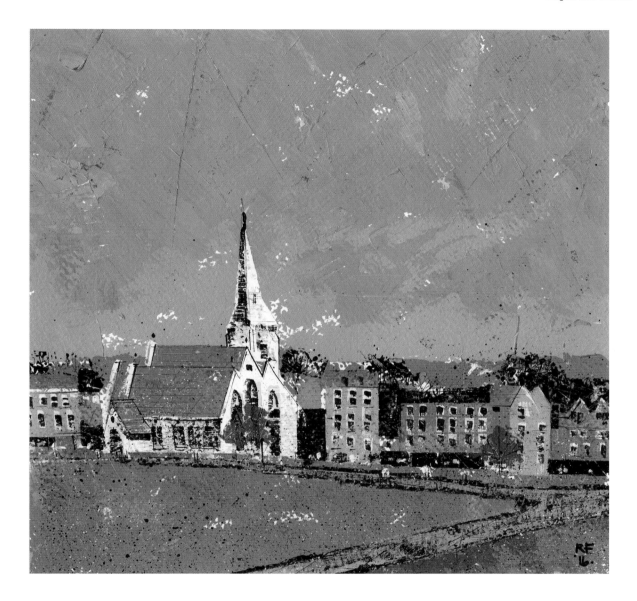

## London's Villages

London has not simply grown outwards from a single central point; smaller, separate settlements have been absorbed into the metropolis, but retain their distinct village-like character. These include Dulwich, Hampstead, Richmond and Blackheath.

Blackheath's origins rely on its proximity to the Roman road, Watling Street, leading from London to Deptford. The road bisects a vast open heath once used as a gathering ground for armies before heading into battle. The Heath is like an upturned saucer, dipping slightly around all its edges, surrounded by Georgian and Victorian houses in brick and stucco. The church of All Saints stands, strangely isolated, on the Heath. Designed by Benjamin Ferrey, it originally consisted of three parallel pitched roofs, resembling a group of Kentish barns; the steeple and spire were added later.

# GOVERNMENT

London's buildings of government reflect the city's changing requirements through the ages — whether for tangible defensive fortifications, demonstrations of wealth, explicit expressions of the democratic processes, fear-inducing grandeur of law courts and prison gateways.

Before the Norman invasion in 1066 the capital of England was Winchester. The Saxon king, Edward the Confessor was attracted by the trade and success of London, together with pleasant and fertile land to the west, upstream from the original walled city. He committed to build an Abbey, the "West Minster", (St Paul's being the "East Minster") on this land, and constructed a wooden palace nearby. This, we can assume, is what was depicted in the Bayeux Tapestry, showing the king in his palace.

Wishing to portray himself as a seamless and legitimate heir to the throne, William the Conqueror took this site as the seat of his government. Not long after, construction of the magnificent new Westminster Hall began and was completed in 1099. Steadily, the centre of government was transferred from Winchester to Westminster, and by the thirteenth century the latter had become the primary royal palace.

Henry VIII developed Whitehall as his main palace but Westminster remained the heart of government, used by the House of Commons and the House of Lords. Law Courts sat in Westminster Hall. Although improvements were made by Wren, Soane and others, the buildings were a jumbled accretion and it was a kind of blessing when fire consumed them, in 1834, to be replaced by Charles Barry's building: a rational expression of the relationship between the two Houses.

London's architecture bears witness to the city's changing governance. From the Lord Mayor of London, traditional figurehead of the City of London Corporation and represented by Guildhall, to the modern-day elected Mayor of London, working in the London Assembly. Various models of government have come and gone: the Metropolitan Board of Works, London County Council and the Greater London Council.

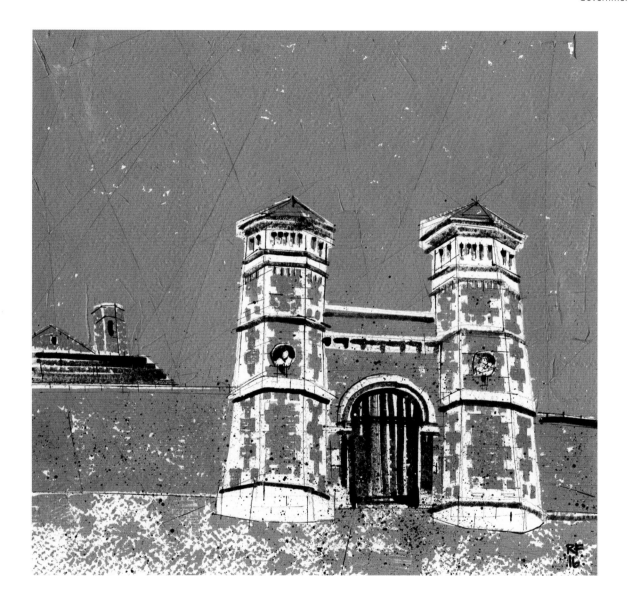

### Prisons: Wormwood Scrubs

The gatehouse at Wormwood Scrubs is a symbol of the English prison system: a richly-decorated focal point to an austere exterior. The central round-arched entrance is flanked by a pair of octagonal towers, inspired by Medieval gatehouses. The red-brown brick facade is relieved by Portland stone quoins, plinths, bands, arcades and cornices. Terracotta medallions depict prison reformers John Howard and Elizabeth Fry.

The gatehouse was built by prison labour and was completed by 1885. The jail itself was laid out in an innovative "telegraph pole" plan form enabling natural light to reach all parts—a contrast to the radial layout frequently used—and became influential internationally.

**Palace of Westminster**

Following a fire in 1834 that destroyed most of the Medieval buildings on the site, Charles Barry won the architectural competition for its replacement. More of a classicist, but conscious of the competition brief demanding a Gothic or Elizabethan style, he astutely appointed Augustus Welby Pugin—devoted to the Gothic style—to work for him on the details.

This was a marriage of complementary talents: Barry able to reconcile the complex functions and hierarchical requirements into a simple formal plan, and the fortitude to cope with Parliament's administrative processes and committees, whilst Pugin's talent was exploited through the preparation of endless ornate Medieval details. The river frontage is picturesque with asymmetrical towers at either end, one the Victoria Tower for the Sovereign's entrance, the other housing the famous clock and bell. Yet, underlying the apparent informality the plan form is ordered and symmetrical, the two Houses placed either side of the Central Lobby.

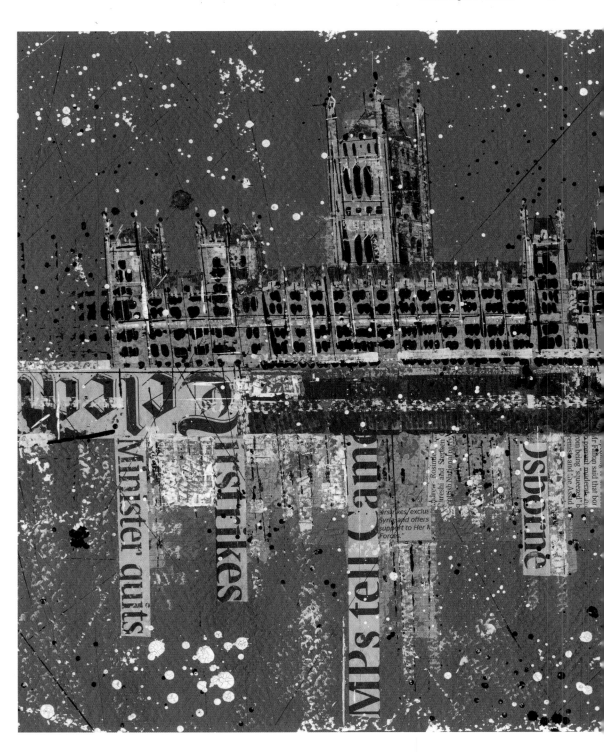

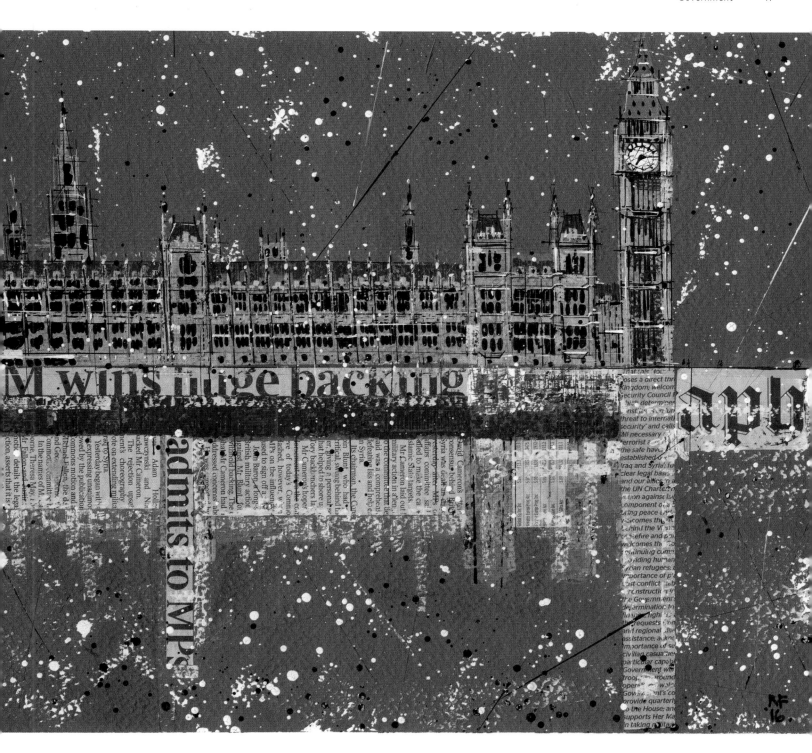

**St James's Palace**

Built in 1531 by Henry VIII on the site of a former leper hospital, St James's Palace became the sovereign's official residence in 1698, following the demolition of Whitehall Palace. Buckingham Palace became the London home of the monarchy when Queen Victoria assumed the throne in 1837.

The imposing gatehouse, in a gorgeous warm red brick, is generally viewed obliquely — from St James's Street. It has pleasing details, featuring half-octagonal turrets with Tudor doorways at their bases, and at the top is a stepped parapet and a clock (1832). The sash windows have been altered over the centuries. On the right of the gatehouse, a massive window serves the Chapel Royal. On the left, the original building line was further back, now concealed behind eighteenth-century additions.

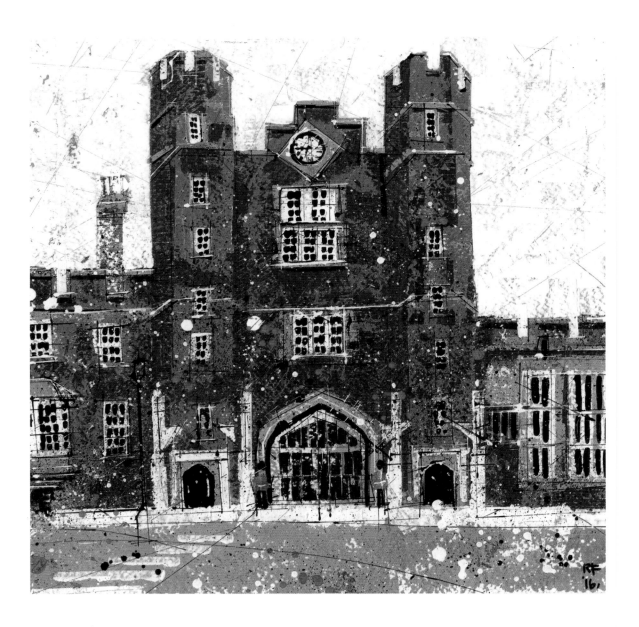

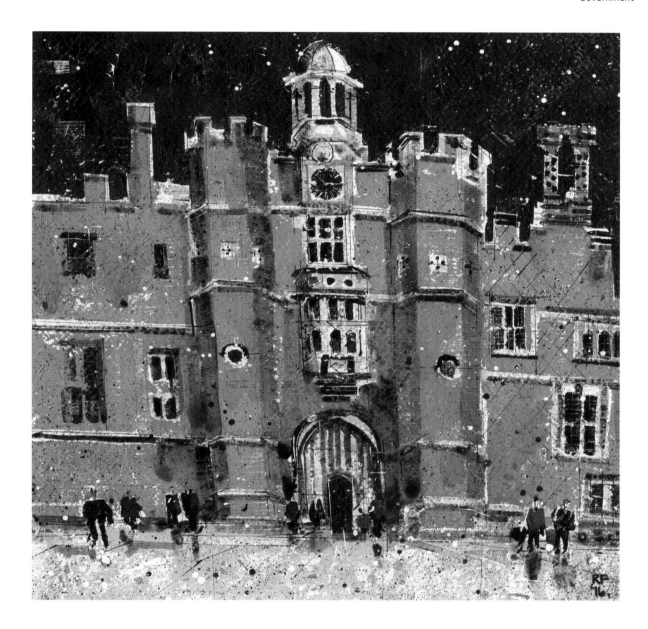

**Hampton Court Palace**

Cardinal Thomas Wolsey acquired modest buildings on this site in 1514 and proceeded to develop them into an extravagant pile, befitting his role as chief minister to Henry VIII. By choice or otherwise, he offered it to the king in 1528. Henry developed the site further, turning it into the grandest of all his palaces.

Anne Boleyn's Gatehouse is the middle gateway in a sequence of courtyards, sitting at the heart of the Palace. Built in a deep red brick it includes a fine and recently restored bell lantern and cupola of 1707 by Sir Christopher Wren.

**Lincoln's Inn**
This is the quaintest building in a cute corner of London. Some of the other chambers facing New Square are in grander and larger buildings—but number 12, with its jumble of different windows, best reflects the quirky individuality of barristers' chambers.

**Royal Courts of Justice**
George Edmund Street won this project in a design competition in 1966–1967 but this was to be no straightforward commission, with client revisions compromising his original conception. The result, completed in 1882, is vast, rambling and rather pompous, but I do rather like the way it relates three-dimensionally to the Strand. The composition of neo-Gothic gables, gateways, towers and turrets combine to generate a facade that is packed with detail, best seen in perspective rather than face-on, whilst the Portland stone is white and pure. The stress of the project is believed to have contributed to Street's death at the age of 57, a year before completion of the works.

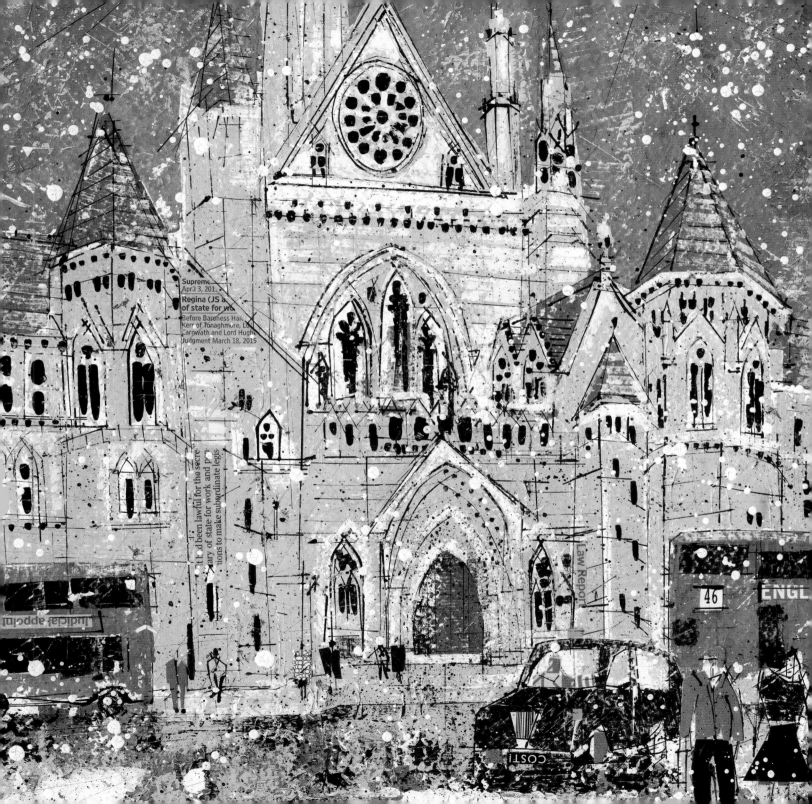

# RELIGION AND CARE

The Church was once London's prevailing social force, and this is manifest in its architectural dominance. The London skyline was punctuated by Wren's churches, and an awe-inspiring sight it must have been. In this, London is not representative of the rest of the country. Wren's churches demonstrate his penchant for Classicism whereas elsewhere Early English Gothic style is most prevalent.

Wren's St Paul's Cathedral is symbolically the most important building in London. It represents reincarnation, the earlier cathedral having been lost to the Great Fire. Wren's creation, with its iconic dome, miraculously survived the Blitz, in spite of being encircled by fire and devastation. As well as representing the country's history and values, the Cathedral continues to house great events, the focus for the nation's greatest joy and grief.

It remains a focal point, with "viewing corridors" a major planning consideration for significant new buildings, to ensure that proposed developments do not intrude into key sightlines to the dome, which looms into view from both afar and nearby.

Needing to accommodate a multitude of different faiths, London has acquired religious buildings to suit all beliefs: from a traditional Hindu temple in Neasden, to a large mosque in Stoke Newington, to the oldest and still the finest synagogue: Bevis Marks in the City (1701).

Religious orders with a strong sense of public duty were the first to provide care for the needy and the unwell, in hospitals that date back to the twelfth and thirteenth centuries. The first owed their origin to the Augustinian monks, at St Bartholomew's in West Smithfield (1123), and St Thomas in Southwark (possibly 1173). They were closed but then refounded by Royal Charter in 1551.

Later, when London grew rapidly in the eighteenth and nineteenth centuries, new hospitals were built at the edge of town to enjoy more expansive sites and plenty of fresh air: for example, St George's to the west (1733) and The Middlesex in the north (1745, closed 2005).

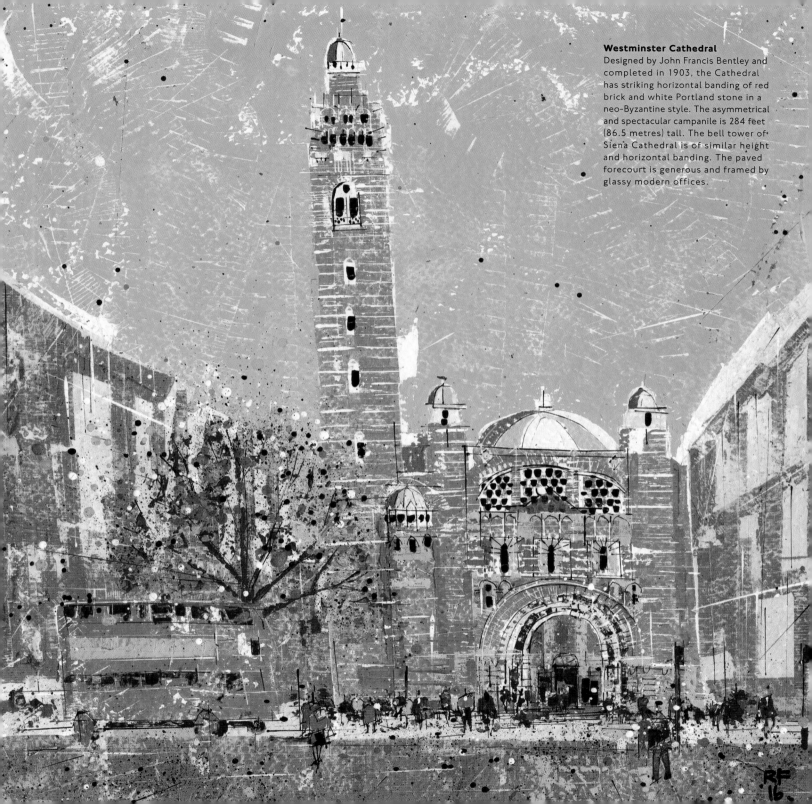

**Westminster Cathedral**
Designed by John Francis Bentley and completed in 1903, the Cathedral has striking horizontal banding of red brick and white Portland stone in a neo-Byzantine style. The asymmetrical and spectacular campanile is 284 feet (86.5 metres) tall. The bell tower of Siena Cathedral is of similar height and horizontal banding. The paved forecourt is generous and framed by glassy modern offices.

RF 16

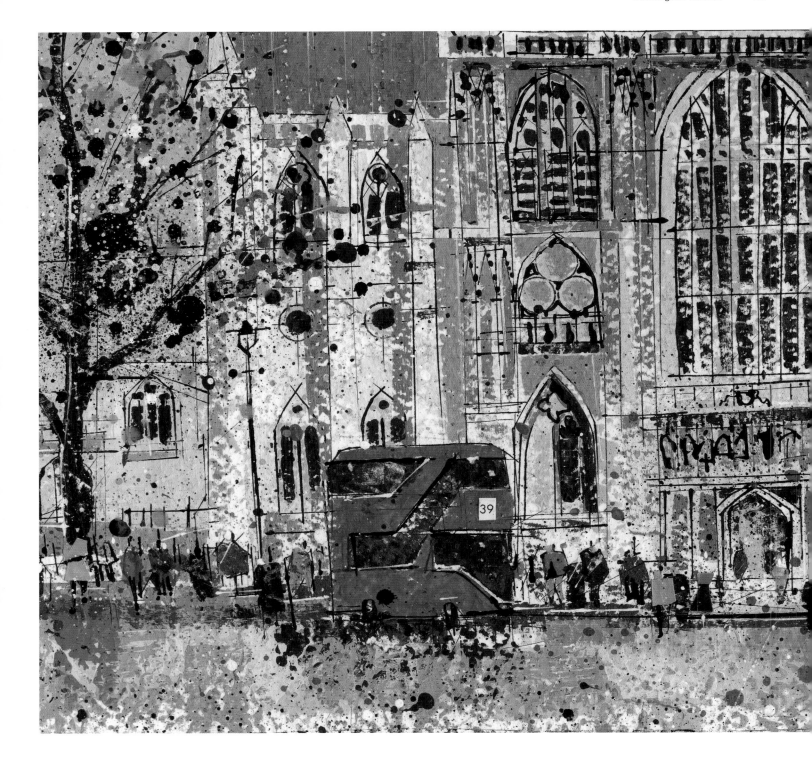

**Westminster Abbey**

The west front of Westminster Abbey was designed by Nicholas Hawksmoor and completed in 1745. The two towers are beautifully proportioned and bring elegance, depth and detail to the facade, acting as a frontispiece to the older building behind.

The spatial composition of the setting is delightful, best seen from where I have painted the scene. Behind the Abbey the other buildings are layered behind, with St Margaret's Church in the middle distance, and the Palace of Westminster looming beyond, with Elizabeth Tower prominent. The cool white stonework of the religious buildings contrasts with the warmer tones of the Palace of Westminster. It is a muted and dignified backdrop to the frenzy of colourful buses, and telephone and post boxes that fill Parliament Square.

**Christ Church, Spitalfields**

This magnificent Baroque tour de force was built to assert the authority of Government and Church over an area of the East End popular with French Huguenots. It is one of 50 new churches commissioned by an Act of 1711 and authorised by Queen Anne to impose religious order on the "godless" of London.

Nicholas Hawksmoor designed a number of these and this was his best. The elegance of the white, well-lit interior is hinted at by the purity of the Portland stone facades. The west front is astonishing in its scale and virtuosity for a mere parish church. The building has thankfully been restored and preserved for the future, after being threatened with demolition since the early 1960s.

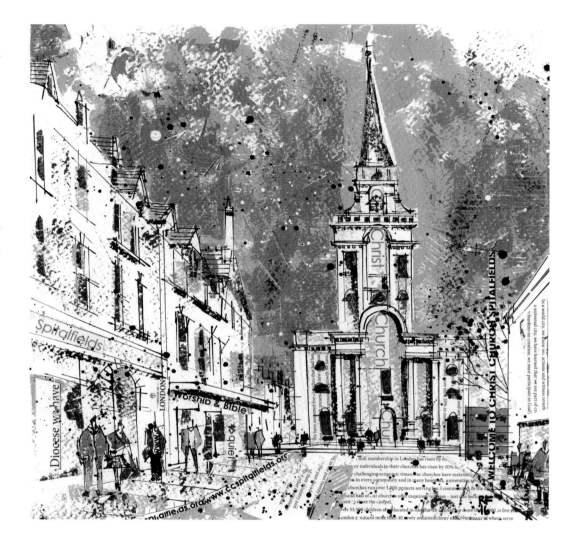

**Cathedrals: St Paul's**

Whilst sometimes the Cathedral's relationship with its surroundings is formal and axial, such as the axis across the Millennium Bridge, the approach up Ludgate Hill is informal and oblique (remaining so, in spite of proposals to straighten it during rebuilding following the Great Fire). The west front is only revealed at the last moment as you approach from Fleet Street, as the curving street opens out into a small square that is surprisingly intimate for such a grand building.

This coyness defies the showmanship of the building. If you contrast inside with outside you will discover how Wren's external grand facades, and even the dome itself, do not truly represent the internal spaces: the aisle ceilings are much lower than implied by the exterior false arcades, and there is a second internal dome, set considerably lower than the external form.

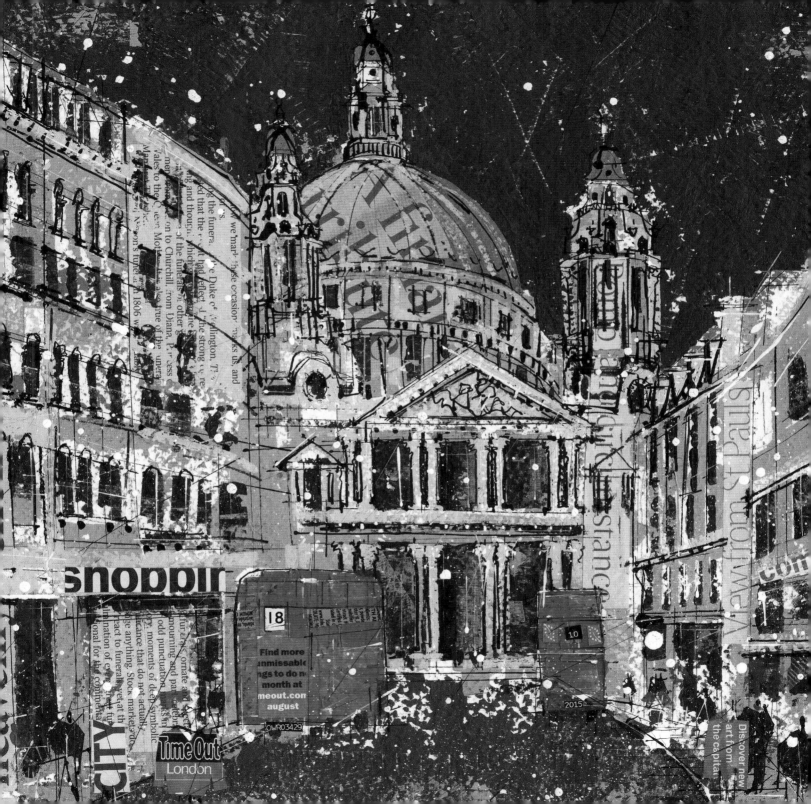

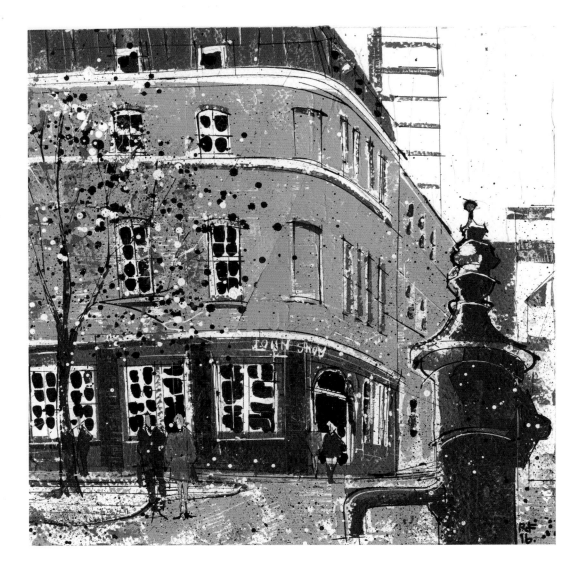

**Disease and Health**

In 1854 Dr John Snow tested a theory. Cholera was a disease rampant in London and the causes were unknown. Snow thought that the origin might be water infested by sewage. Following an outbreak in Soho, he produced a local map to demonstrate that the victims were clustered around a water pump on Broadwick Street.

By making this connection between water quality and disease, Snow made a major contribution to the health of Londoners. A replica pump, close to the site of the original, commemorates Snow's discovery... and a pub is named after him.

# WORK

London owes its origins to trade: produce brought in by sea, unloaded, stored and sold in great specialist markets. These processes have now changed but the architectural heritage of wharves, warehouses and markets survives, relics of bygone working practices.

It was also London's importance as a trade-centre that first led to its emergence as a market for specialist insurance. A coffee house, run by Edward Lloyd, had by 1688 become recognised as the place to obtain marine insurance, and soon it was the place to go to obtain specialist insurance of any kind.

Over the past century the City has been immensely successful in growing financial and insurance services so that London excels in a global market. Walking round the City during the working day it seems a terribly serious and important place, the engine room of the capital. Architecturally, it is a challenge to reconcile the need to create large trading floors and modern flexible working spaces — needed to maintain international competitiveness — within the planning constraints of a Medieval street pattern and policies to retain key sightlines to St Paul's Cathedral. Yet, somehow, it manages to marry these conflicting demands.

The West End, by contrast, enjoys a reputation of being more relaxed and fun. In its own way it is just as successful, with creative industries flourishing, again internationally. Thanks to a growing economy and increasing wealth the shabbier parts of London have become edgy and trendy, the new place to be. I have seen first Covent Garden, Soho and Clerkenwell, then more recently Old Street, London Bridge, Bermondsey and Shoreditch become the focus for media and design industries, and where they lead others soon follow. Old, robust buildings can be beautifully combined with overtly modern structures, functional and sharp in contrast with the patina of age. The style of such interventions is now well-established; modernism complementing the historic.

These are the places where ideas are formed, where creative industry can thrive. But there is a threat too: as rents rise, Soho's bohemian character is in danger of being squeezed out by bigger businesses. The nature of the buildings will help preserve the visual character, and retaining small quirky buildings reduces the attractiveness to large corporate occupiers.

**The City and Change: Royal Exchange and Mansion House**

The combination of the Great Fire, war bombing and commercial opportunities have led to the constant rebuilding of the City, mostly within the original street pattern. From Wren to Mies van der Rohe there have been grand plans to realign streets and create formal squares. The most radical plans to be actually implemented were Queen Victoria Street and King William Street cut diagonally through the City by the Victorians to converge here, at the Bank of England. Original Roman roads, Cheapside, Cornhill and Poultry, survive.

The Royal Exchange of 1844 (the third version on this site, the first two having been lost to fire) is dwarfed by modern towers behind: thankfully excellent buildings designed by Britain's best two architects of the modern era, Lords Foster and Rogers (the curvaceous 30 St Mary Axe, or the "Gherkin", by the former, and the angular 122 Leadenhall Street, the "Cheese Grater", by the latter). A scrum of cranes is currently gathered behind the Mansion House, and soon a new edifice will thrust skywards.

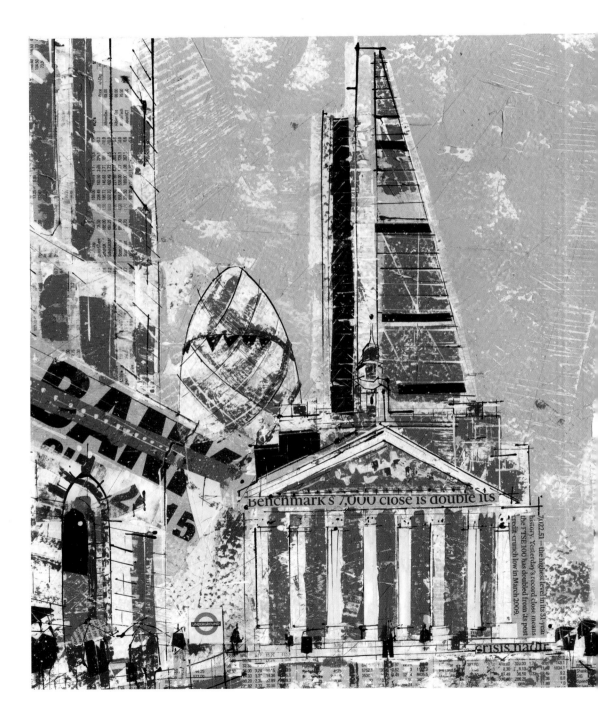

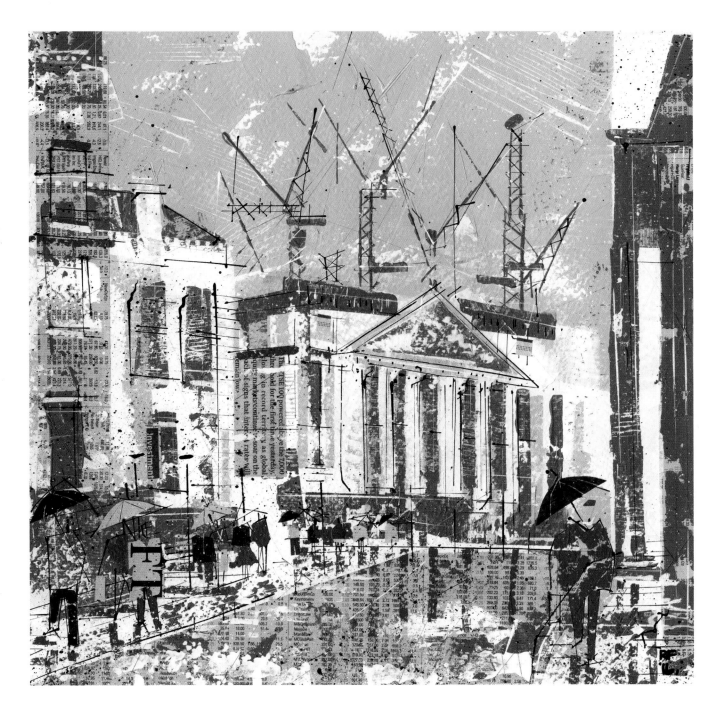

## Shad Thames

Great buildings survive change. Shad Thames was once an area of intense activity, with wharves and cranes on the river frontage allowing boats to unload their cargo directly into tall warehouses. These backed onto narrow cobbled streets, with more warehouses, mills, granaries and factories on the opposite side; iconic cast-iron bridges providing connections across the streets at upper levels.

This hive of activity was labour intensive—and by the 1970s, when the business of container shipping had moved further east, it declined. Thankfully, new uses have been found for the buildings: cafes, shops, flats, studios and offices have attracted investment. Fundamentally robust and well-built, the old warehouses have retained much of their original detail, texture and character, and where dockworkers formerly toiled and strove, office workers, tourists and residents now saunter.

**Icons of the City (overleaf)**

The best panorama of London's skyline is from Waterloo Bridge. With the dome of St Paul's to the left, a cacophony of new building shapes compete for attention, given nicknames according to their external form: the Shard, Cheese Grater, Walkie-Talkie and Gherkin. This trivialises the thought and design process that has created those shapes.

Whilst the NatWest Tower (now known as Tower 42) by Richard Seifert and completed in 1980 was for three decades the highest building in the City of London, the new trend for adventurous shapes and vertical expansion was begun by the distinctive 30 St Mary Axe by Foster + Partners in 2004. This is a sophisticated and elegant building, the gherkin-like shape the consequence of aerodynamic considerations, and rational desire to pinch the form in at the base to create a public realm at ground level, widen it to a greater girth to create efficient lettable floor areas, with a smoothly-narrowing culmination in a cafe/bar at the top. The diagonal pattern to the facade reflects the building structure and a series of spiralling atria that link the office floors. The Shard by Renzo Piano is an equally attractive and instantly recognised silhouette when viewed from afar, but closer up the detail is really rather ordinary. 12 Leadenhall Street — or the "Cheese Grater" — by Rogers Stirk Harbour + Partners, complements the same practice's Lloyds Building opposite. Its grand gesture is the devotion of the lower levels to the creation of a vast five-storey high covered public realm, with offices towering above.

The "Walkie-Talkie" by Rafael Vinoly is discordant. Its bulbous form is based on the premise that the greatest value is highest up, so the building widens to create a top-heavy shape that lurches uninvited into view.

As I walked across Waterloo Bridge, eyeing up the best viewpoint, a passer-by tossed some crumbs into the air for the birds. I wonder, will these modern architectural icons be equally transitory, fleeting random shapes cast across the skyline?

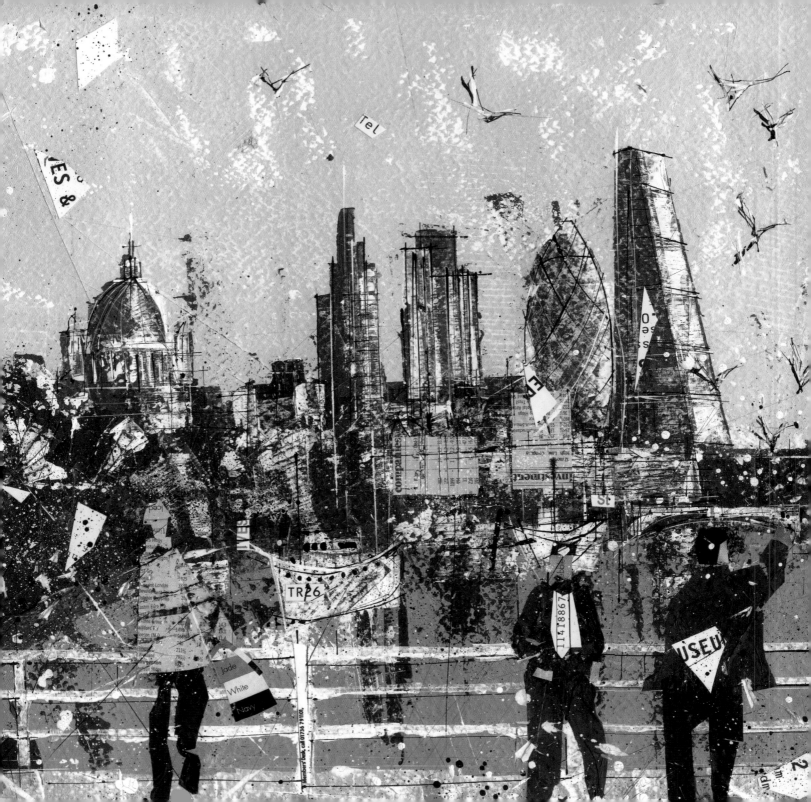

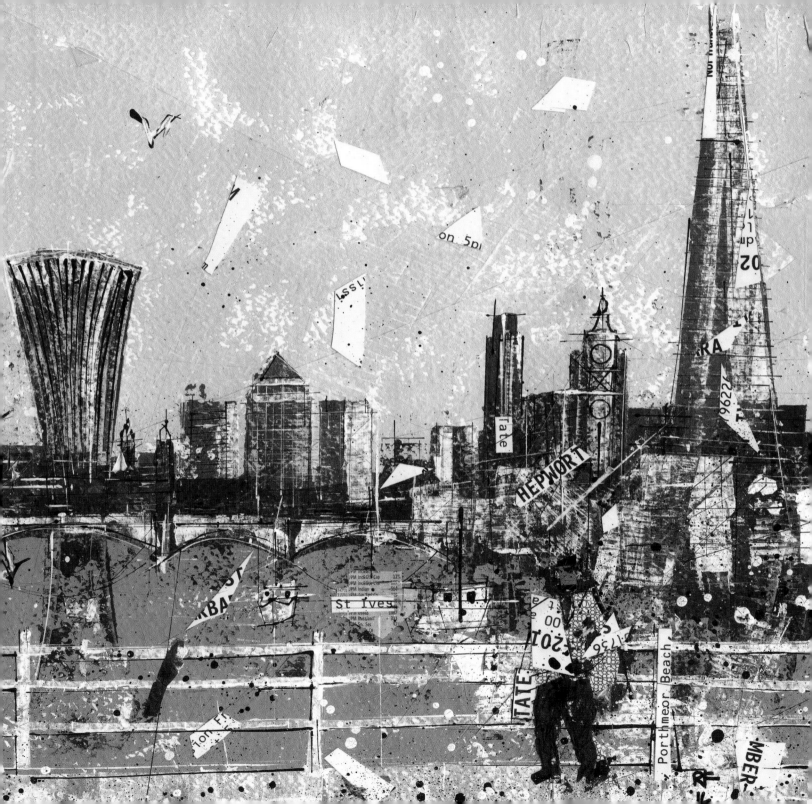

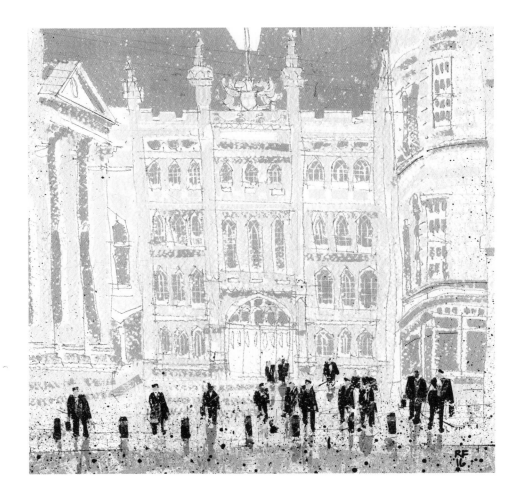

**Guildhall**

Emerging into bright sunlight after lunch, I saw this scene in rather black and white terms: the silhouettes of human forms a shadowy contrast to the ghostly backdrop of the pale stone Guildhall behind.

This has been the administrative and ceremonial centre of the City for more than 800 years, the power-base for the Lord Mayor of London and the City of London Corporation. The main hall, built 1411–1440, holds great banquets and other important events.

**Regent's Canal, Camden Lock**

In some cities — Manchester comes to mind — the canal network is like a separate world: an intricate network of waterways and towpaths operating at a sub-level to the surrounding streets and railways to the rest of the city. You don't get the same sense of other-worldliness in London. The Regent's Canal, where it passes through Camden Lock, has a sense of calmness and history when it is quiet, and the architecture of the locks, bridges and warehouses can be appreciated. But on a Sunday afternoon when the place buzzes with life and activity the setting is merely a backdrop to the food, performers and crowds.

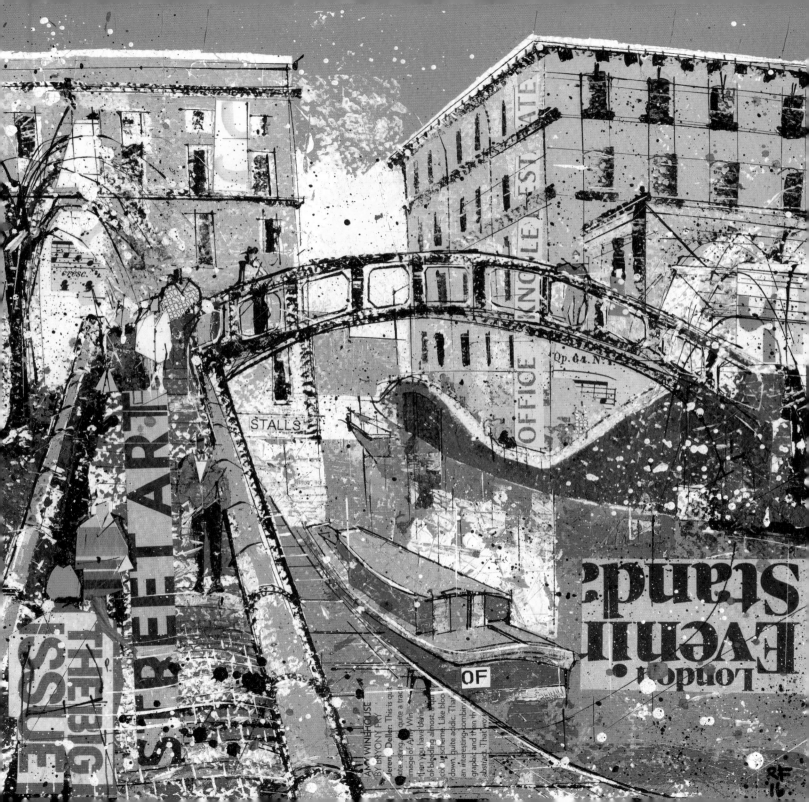

**Borough Market**

I am lucky enough to work just five minutes from here. I love the shambolic layout, the smells, the sounds and the bright colours contrasting with the rough textures and patina of old brick walls and steelwork to the railway arches overhead. The market's origins go back at least a thousand years, but it has been a specialist food market since the nineteenth century, taking advantage of the close proximity of riverside wharves and the exciting foods imported.

London had a series of specialist markets, built in the eighteenth and nineteenth centuries to provide produce for the growing population, such as fruit and vegetables at Covent Garden, fish at Billingsgate, meat at Smithfield. As these have relocated—Covent Garden to Nine Elms in Vauxhall for example—the old warehouses have faced demolition and the imperative of finding new uses.

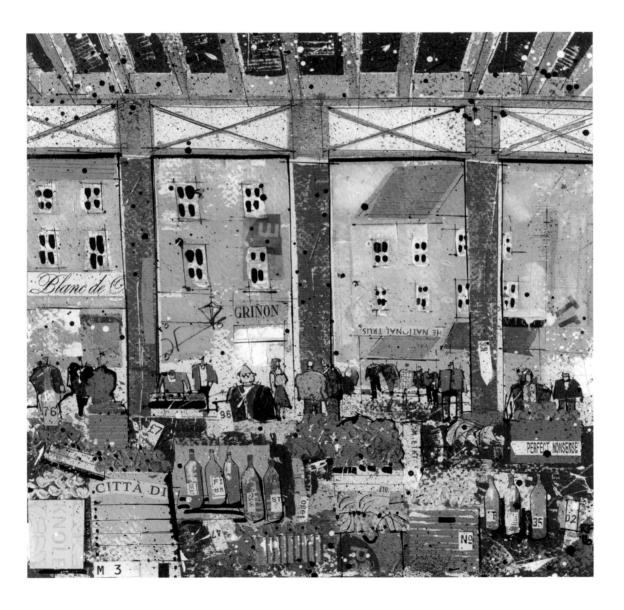

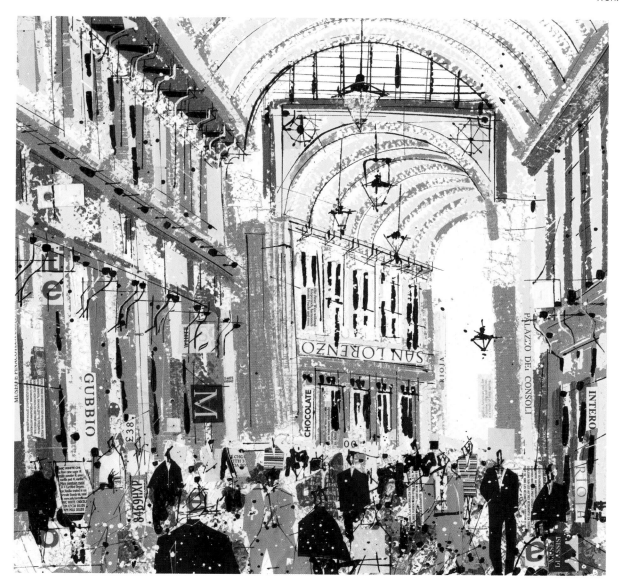

## Leadenhall Market

Located at the heart of the original Roman settlement, this market has been here since at least the fourteenth century. Once specialising in meat, game and poultry, like other London covered markets it is now focused on the tourist and lunchtime office worker trade, selling high-quality food and offering bars and cafes. The glass-roofed, brightly coloured structure is dated 1881.

London's great Victorian buildings—markets, warehouses, railway stations and so on—lose something of their gutsy, gritty toughness if they have to safeguard their futures by being reinvented and somewhat manicured as retail and restaurant venues for city workers, weekenders and tourists.

# LIVING

London is a place of contrasts, and in no aspect is this more profoundly evident than in its residential accommodation. Exceedingly wealthy areas are juxtaposed with far less salubrious places, each tolerant of the other, and London the better place for it.

London houses the Royal Family and individuals of vast wealth from home and overseas, in palaces, castles and grand residences. Terraced houses are joined into vast blocks that appear much more imposing as a group than they ever could individually. Even the mews houses and terraces, once for servants and tradesmen, are now highly sought-after.

London is like a series of concentric layers. The historic centre, once contained within the walls, is dense and organic in layout, is now the business and cultural heart. When expansion burst out beyond the corset-like constraint of the defensive walls, the next zone was more spacious, the formal squares and terraces of Georgian development, interspersed with large parks.

As land became more valuable, the next phase saw more intensive use of land with the advent of the mansion block. Typically on around 6–8 levels, large flats were arranged either side of a central stair and lift.

Then, further out and served by the railway and Underground lines, suburban London sprawls with first a layer of Victorian development, then twentieth-century housing extending for street after street, submerging older settlements into the great metropolis. Thankfully, a Green Belt was put around London in 1947 to constrain further outward expansion.

The suburbs embody the aspiration of the majority to have their own house and garden. This consumes vast amounts of land. It is perfectly possible to create attractive places to live at high density: Kensington and Chelsea are exemplars of intensive land use whilst still being an attractive environment in which to reside. Outer suburbia, dating from the 1930s, is not: built at low density, lacking identity and individuality. If London's population continues to grow, increasing density around transport hubs and densification of suburbia are the way forward, and encroachment into the Green Belt should continue to be resisted.

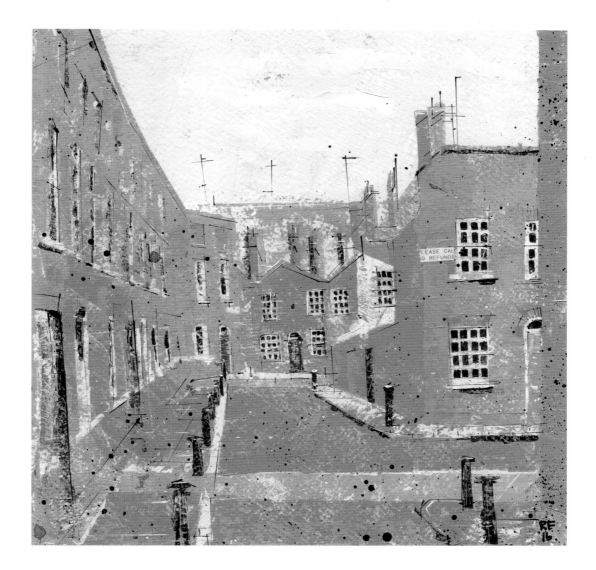

## Roupell Street and Area

Just to the north of Waterloo East station lies an extraordinary area of pure early nineteenth-century housing, which has somehow survived both bombs and developers. There is an evocative view across the rooftops and slender chimneys from the elevated railway viaduct.

The area was first developed by John Palmer Roupell, a gold refiner who built modest brick terraced houses for artisan workers. Reflecting their relatively low status, the houses front right onto the street.

In spite of the utilitarian nature of the buildings, clever design has provided attractive variations. In Roupell Street the houses have roofs at right angles to the street. Each house has two roofs sloping towards the centre where a valley gutter drains to the rear of the property. This "butterfly" roof form is expressed on the street frontage, giving a pleasant rise and fall to the profile of the roof.

By contrast, in Theed Street the eaves line is constant. These houses have monopitch roofs that run parallel to the street, sloping down, away from the frontage. This creates extra height at the front, which is exploited by "blind" (false) windows at second floor level—introduced to make the house appear taller and grander than it really is.

## Lord North Street

Architecturally distinguished and historically significant, Lord North Street is defined by parallel terraces of excellent Georgian houses, built in the 1720s. The view along the street southwards is nicely closed-off by the Baroque St John's Church in Smith Square.

Being so close to Westminster, the houses are popular with MPs with consequential associations with various stories of political intrigue and farce. Harold Wilson, moved to number 5 after losing the 1970 General Election; when re-elected Prime Minister in 1974 his wife refused to move back to 10 Downing Street, so their house became as much a focal point for government as the official Prime Ministerial residence.

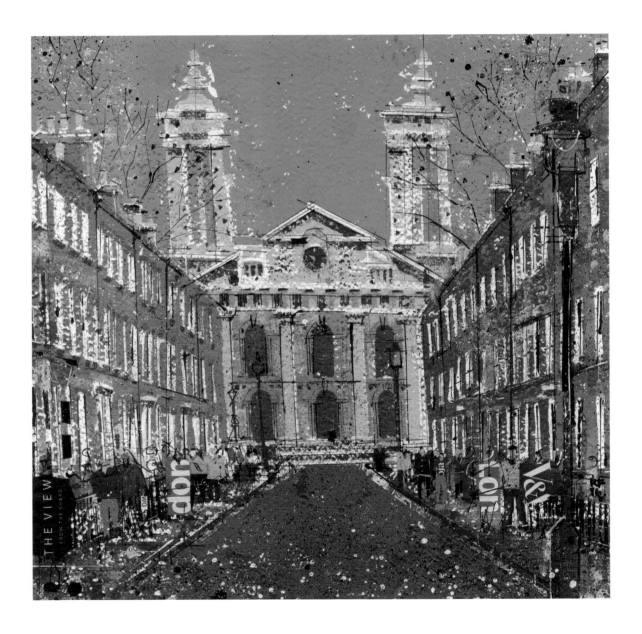

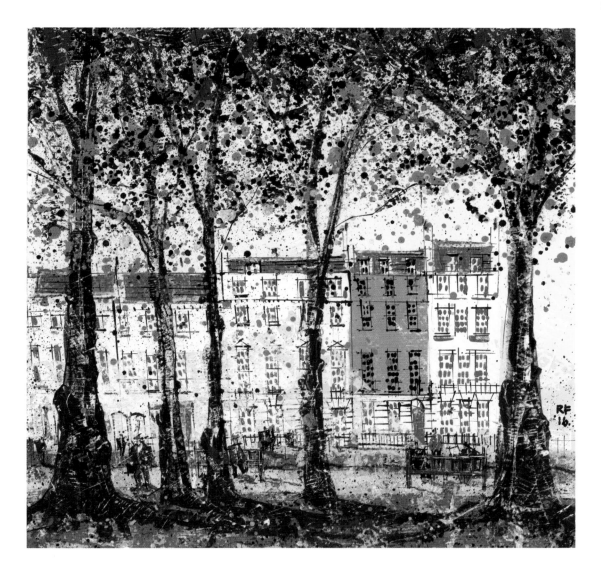

## Berkeley Square

The best surviving houses at Berkeley Square are on the west side, where they can be glimpsed through the vast shaded canopy of magnificent plane trees. The Square was laid out in the eighteenth century by William Kent. It is relatively long and thin, slightly inclined to the north. Occupants of the square include a childhood home (number 48) for Sir Winston Churchill, and Robert Clive of India died—it is believed by his own hand—in number 45 in 1774.

Plane trees, with their blotchy lumpy trunks and huge lobed leaves, are an eighteenth-century hybrid. None have yet died from old age, so we don't yet know how long they will live for. Those in Berkeley Square, planted around 1789, are the oldest and finest in London. Because their bark flakes off they have been able to withstand the pollution of the city, pollutants simply discarded with the bark, to reveal a light fresh trunk beneath. In an attempt to challenge instances of wanton loss of trees the London Tree Officers Association attempted to assess their monetary value; one in Berkeley Square reached the highest in the country, at £750,000.

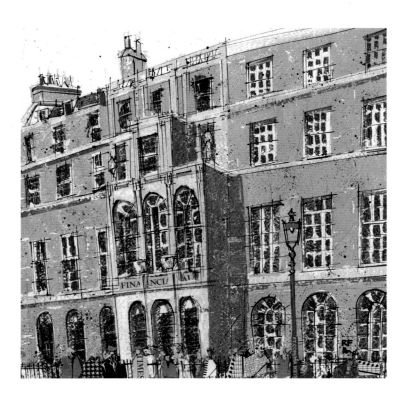

**Sir John Soane's House and Museum**
Soane practised as an architect in the
early eighteenth century, when the Gothic
Revival began to succeed neo-Classicism.
Soane favoured the latter, and used his own
home to showcase his beliefs: a succession
of extraordinary interior spaces, ingeniously
top-lit and with judiciously-placed mirrors,
packed with Soane's eclectic collection of
models, casts, statues, pictures, fragments
and all sorts, and preserved as he left them
to the nation in 1837.

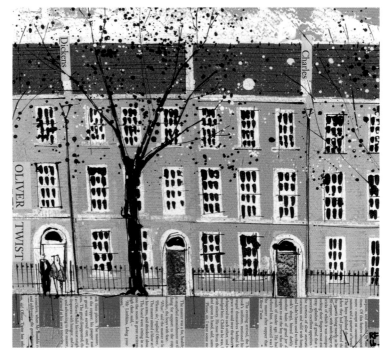

**48 Doughty Street: Dickens' House**
An ordinary early nineteenth-century terraced
house in Bloomsbury was Dickens' home
as he was becoming famous. This is where
he wrote some of his finest work, including
*Oliver Twist*, 1838. Saved from demolition,
it opened as a museum in 1925, with some
rooms preserved as Dickens left them—giving
an insight not just into his life but also a
sample of a typical Georgian house interior.

**Bywater Street, Chelsea**

Just to the north of King's Road in Chelsea, Bywater Street is a lesson in good presentation. Individually the terraced mews cottages are tiny, the front door opening straight into the main reception room, and a winding staircase providing access to small bedrooms. But the bright complementary colours give the street a unified and jolly appearance.

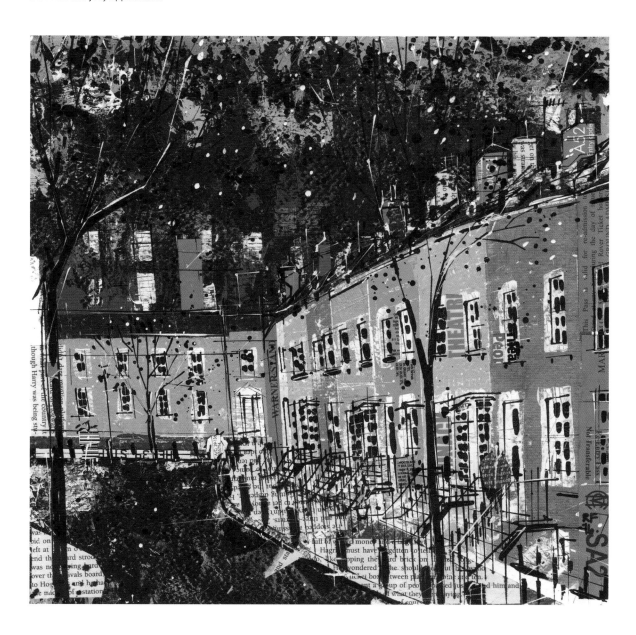

**St Pancras Hotel**

This lavish High Victorian neo-Gothic extravaganza of a hotel marks the terminus of the Midland Railway. Designed by Sir George Gilbert Scott, inspired by the Gothic Revival Palace of Westminster, it is built in red brick, representative of the Midlands region it serves.

Having opened in 1873 the hotel gradually declined and closed in 1935. The building was threatened with demolition—described by Sir John Betjeman as a "criminal folly"—but the building was rightly listed, Grade I. The turning point in its fortunes arrived with the Eurostar, which terminates at St Pancras, helping to justify a spectacular refurbishment enabling the hotel to reopen in 2011.

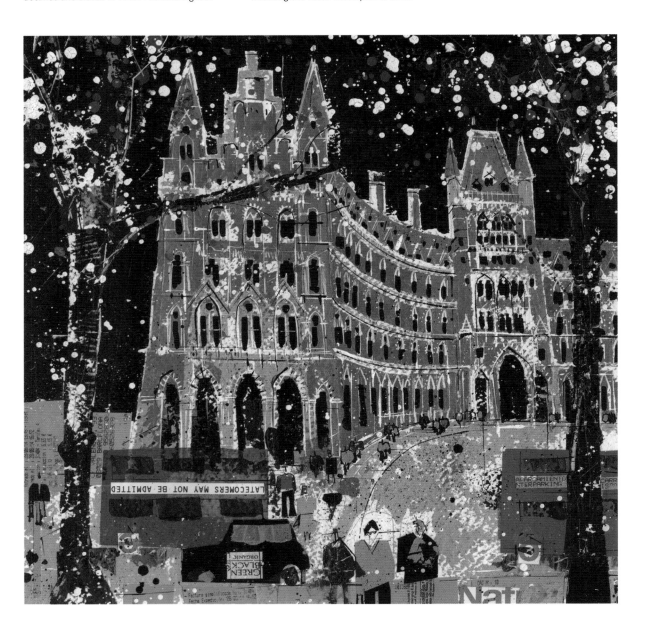

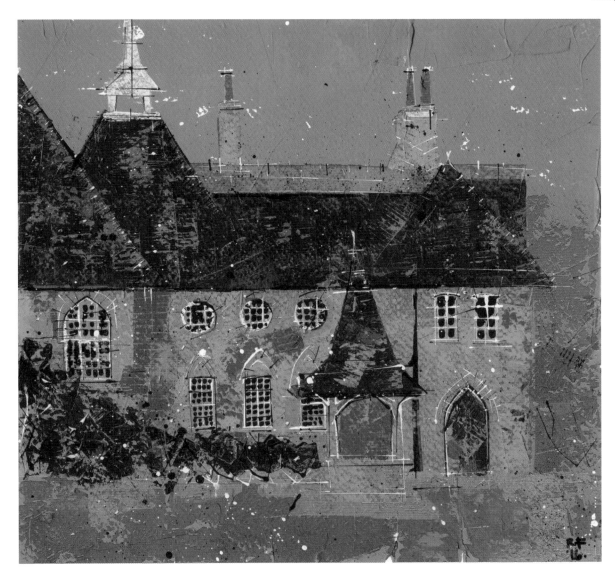

## The Red House, Bexleyheath

This house was designed in the Arts and Crafts style by William Morris for his family, in collaboration with Philip Webb. When it was built in 1860 it was in a small hamlet but it is now surrounded by suburbia. L-shaped in plan form and thereby partially enclosing the garden, the arrangement of turrets, gables, steeply pitched roofs, hips and ridges creates an irregular, organic composition. It reflected what Augustus Welby Pugin had argued in *Contrasts*, 1836, and demonstrated in the design for his own family home, The Grange, in Ramsgate, 1843–1844. Pugin, then Morris, believed that to achieve architectural beauty a design should be appropriate for its purpose, and ornament should only be used to enhance a building's essential construction. At the Red House, the use and detailing of brickwork, joinery and metalwork are exemplary.

The exterior is an honest expression of the internal arrangement, where the rooms flow one into the next in an almost modern manner, and the design of the servants' quarters reflects a liberal attitude. The design considers the relationship of buildings with the environment, anticipating similar themes seen years later in the Hampstead Garden suburb, and challenges that face us today.

## Bedford Park

This remarkable and highly influential experiment in a new way of living was inspired by the visionary writing of William Morris. It was the brainchild of developer Jonathan Carr, with key parts designed by Richard Norman Shaw. Started in 1875 on 24 acres to the north of Turnham Green underground station, the site layout allowed for the retention of large mature trees.

The houses incorporate Queen Anne revival and Flemish influences, with ornate Dutch gables, tall chimneys, rubbed brick arches, tile hanging, balconies, bay windows, deep porches, wooden fences and well-stocked gardens. No wonder many others were envious of the sense of community and the idyll of living in an individual house set in its own garden, with easy access to both countryside and central London.

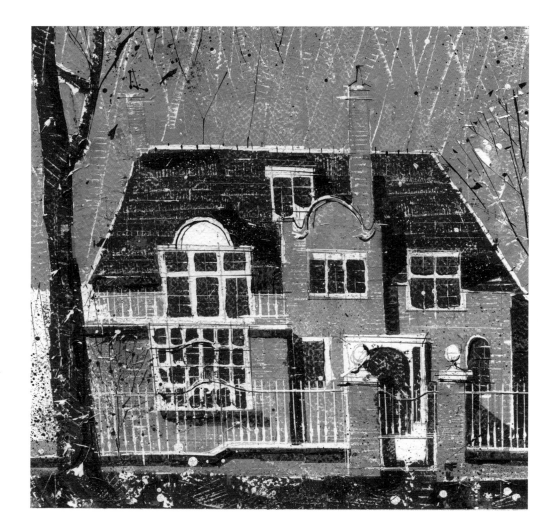

## Pepys Road, Telegraph Hill, New Cross

The central core of London is surrounded by Victorian suburbia. This actually works extremely well: rows of terraced and semi-detached houses are grouped around parks, shopping areas, churches, sports facilities, supermarkets and—most essential of all—railway stations. There is a sense of separate districts, defined by major arterial roads, railway lines and open spaces, distinguishing Clapham from Wandsworth, Balham, Streatham, Brixton and so on.

The Victorian house plan is rather clever, minimising circulation and using half-levels on the staircase to deal with changes in site levels. Typically, two floors at the front—living rooms and main bedrooms, with high ceilings—transform into three lower levels at the rear—kitchen and two floors of bedrooms.

This is an example, in Telegraph Hill, New Cross, chosen for no better reason than that this is where we lived for five years. When we moved in, it had a green door. We painted it yellow. Now we have moved on, it is red. So, we all impart our individuality on a house, otherwise identical to thousands of others across the capital.

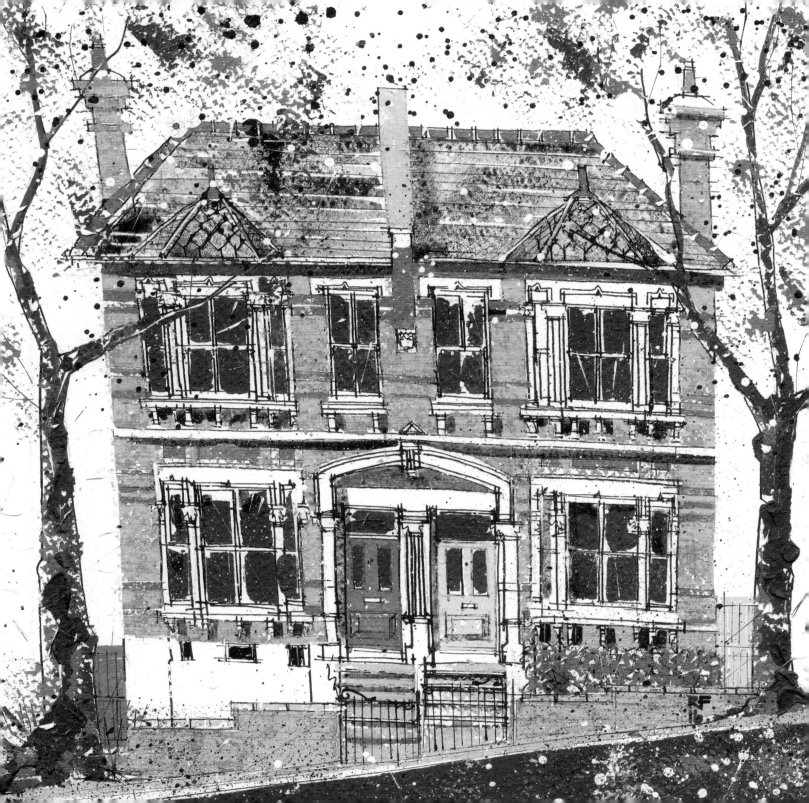

**Little Venice**

This is a tranquil and picturesque corner
of London, with white stucco villas and
colourful houseboats reflected in the
still water of Paddington Basin. This is
where Regent's Canal, which was created
in 1820 to form a link to the Thames at
Limehouse, meets the Grand Union Canal.

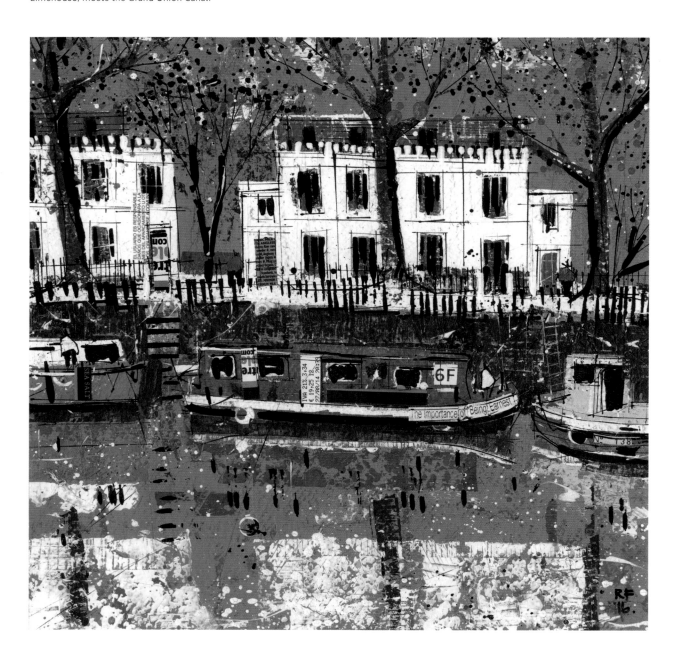

## The World's First Council Housing: Boundary Street Estate

London was growing rapidly in the second half of the nineteenth century but a large proportion of its population was living in extreme poverty. This was analysed by Charles Booth through a series of fascinating colour-coded maps, categorising residents from "Lowest class. Vicious, semi-criminal" to "upper-middle and upper classes. Wealthy".

Areas such as the Old Nichol slum in the East End were notorious no-go zones, reinforced in novels such as *A Child of the Jago*. It was replaced by The Boundary Street Estate, lovely red brick Arts and Crafts-influenced tenements with Dutch gables, steep roofs and elegant chimneys, approved by the then new (and subsequently abolished) London County Council. The red-bricked flats radiate out from Arnold Circus, which provided a community focus with big trees, gardens and a bandstand.

**Dorchester Hotel**
The Dorchester was built in 1930–1931 to the designs of an engineer, Owen Williams. Modern and with Art Deco touches, the interior is frivolous and flamboyant, and has been subject to various refurbishments (I spent a year working on one, in 1980–1981), all less successful than the exterior. The gently-curving entrance facade neatly turns away from Park Lane to focus on a small garden to the south. One of the great, prestigious hotels of the world, the Dorchester is significant more for the fame of those who have stayed here than for the splendour of its architecture.

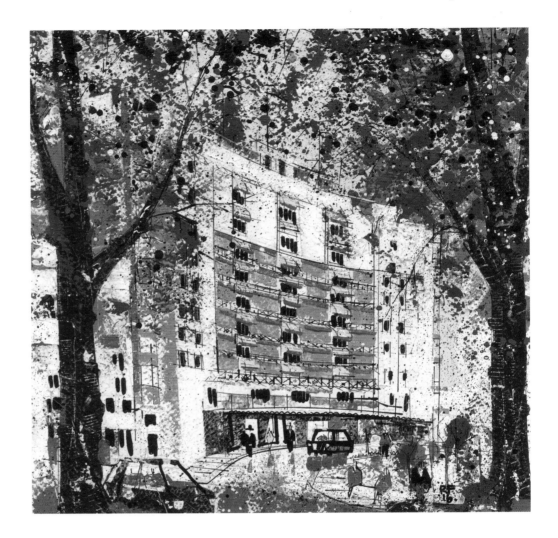

**Hampstead Garden Suburb**
With its origins in the layout of St John's Wood, a radical new way of living was advocated by socialist planners at the beginning of the twentieth century, exemplified by Barry Parker and Raymond Unwin's Hampstead Garden Suburb, 1907. This offered Londoners an escape from the pollution, dirt, disease and vices of the metropolis, by providing them with compact cottages set within individual gardens in which to grow food, play sport and pursue leisure activities in fresh air.

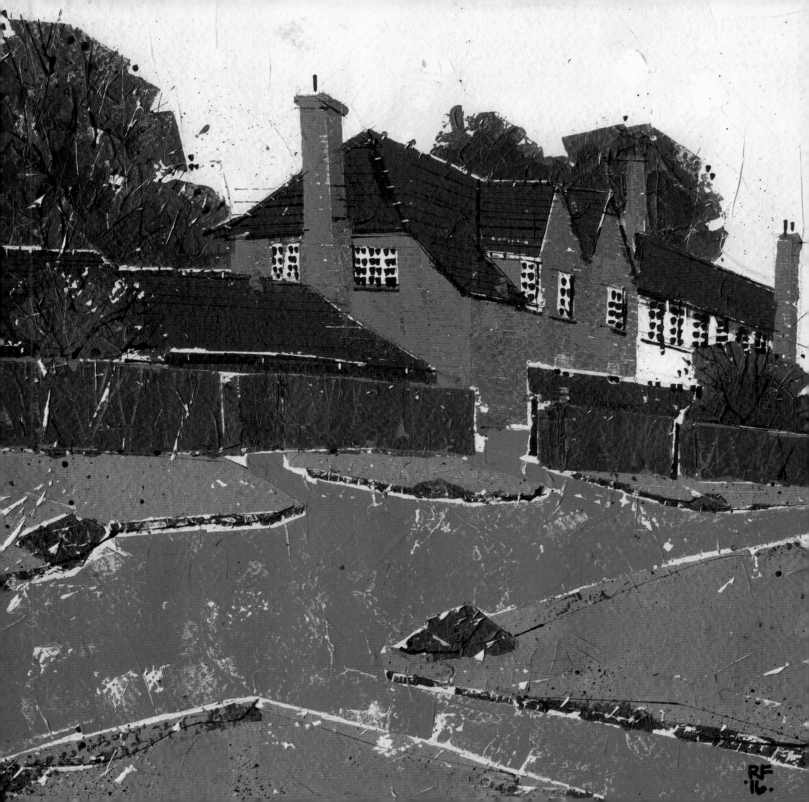

# KNOWLEDGE AND CULTURE

London is diverse and tolerant. By invasions and infiltrations it has had to gradually absorb different cultures, and has thereby been enriched. In the late seventeenth century, fleeing oppression in Catholic France, Protestant Huguenots settled in Spitalfields, just outside the City Walls, where housing was cheaper. They brought a bohemian outlook and specialist skills in silk weaving, and built for themselves distinctive houses with extra-wide top floor windows for good natural light by which to weave.

As well as providing a refuge, the capital has long been a magnet for formal teaching and self-motivated learning. With over six million visitors, the successful Great Exhibition of 1851 made sufficient profits to enable the purchase of 87 acres nearby, in South Kensington, and the aims of the Exhibition were carried forward with the construction of great museums, a performance venue and university buildings (Victoria and Albert, Natural History and Science Museums, the Royal Albert Hall, Royal College of Music and Imperial College).

London is well-endowed with other great museums: the British Museum, the Maritime Museum in Greenwich, the Imperial War Museum, the Design Museum and the London Transport Museum, together with smaller local museums like the Horniman in Forest Hill and the Geffrye in Hoxton.

Its galleries are just as impressive: the National Gallery, National Portrait Gallery, Tate Modern, Tate Britain, Royal Academy and Courtauld Institute of Art some of the best-endowed in the world.

The great museums and galleries are grand, formal and imperialist. By contrast, London also offers the intimacy and immediacy of its street artists, buskers on the Underground, carnivals, fashion shows, bookshops, theatres, music venues, cinemas and concerts.

Great advances in education were made in Victorian times. The School Board for London was established in 1870 and paid great consideration to the curriculum and the buildings needed to accommodate nearly half a million children, who were still not receiving an education. The Board appointed as its architect ER Robson, who evolved a standard approach capable of adaption to different sites and requirements.

Robson's solution was based on a plan arrangement in which boys and girls were separated and classrooms were high, bright and airy. The buildings were dressed in a Flemish style with expressive gables, ornate brickwork and terracotta features. Three storeys high and with tall windows the schools looked impressive: sturdy, well-built, practical and dominating their surrounding communities they are, frankly, better than many of the schools we are building today.

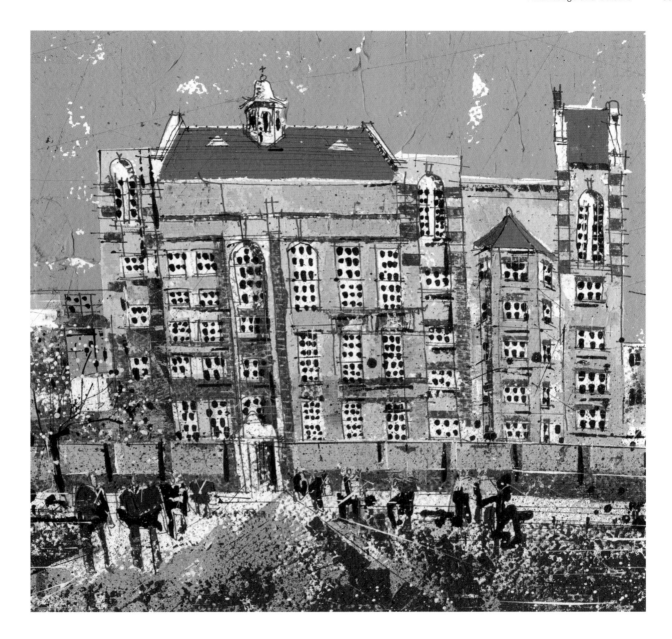

**Board Schools**

In 1870 the Education Act established a system of school boards to build and manage schools; in 1880 school attendance was made compulsory between the ages of five and ten.

The School Board for London under ER Robson ensured provision of the Board Schools with a recognisable Queen Anne style: with generous floor to floor heights, red bricked elevations and steeply-pitched slate roofs and the separation of boys and girls. The schools were functional and distinctive.

## Tate Modern

There is a perfect chemistry between the colossal former Bankside power station by Sir Giles Gilbert Scott and the modern works of art it now houses, following Herzog and de Meuron's well-judged £134 million conversion.

The former turbine hall is a cavernous space, 35 metres high and 152 metres long, a perfect space for contemporary art. With the floor at basement level the full width of the floor is cranked upwards to form a massive ramped access from ground level. Alongside and parallel with the river, the boiler house forms the series of galleries. The central chimney — the original concept showed two, at either end — acts as a 99-metre high beacon.

The original building itself is relatively modern, built in two phases, 1947–1963.

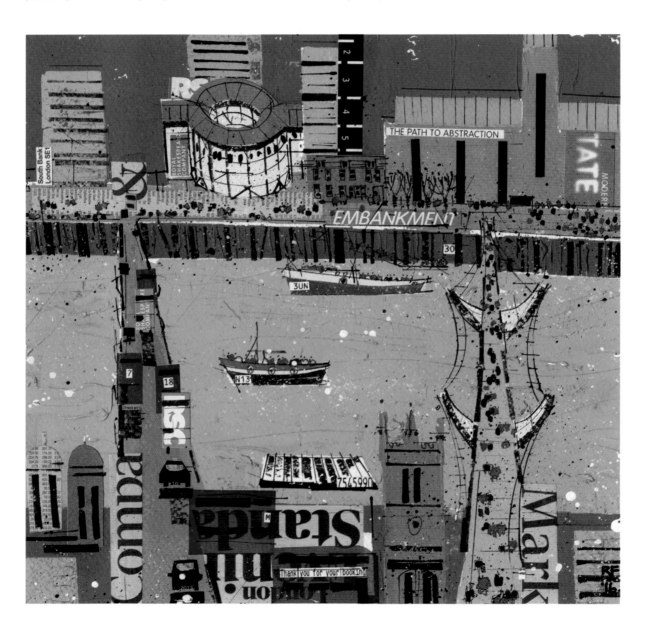

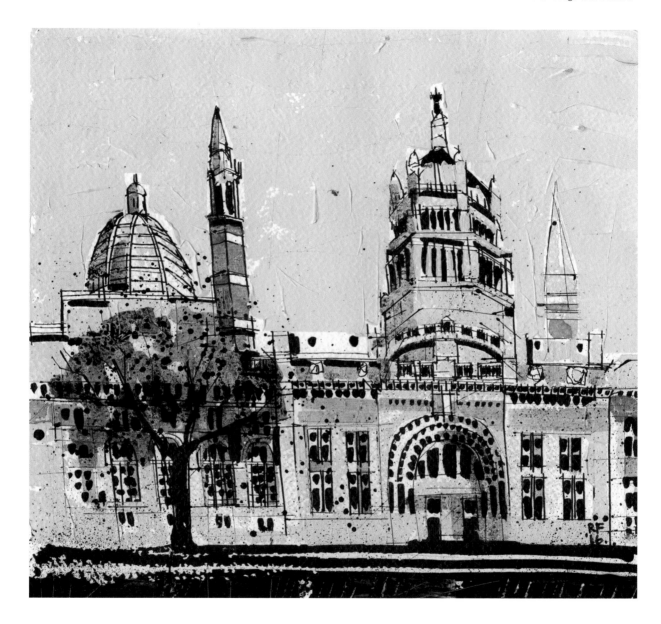

## Victoria and Albert Museum

The Victoria and Albert (V&A)'s mission is to be the world's leading museum for art and design. Its origins can be traced back to 1836 when a House of Commons report concluded that insufficient attention was paid to good design, and the foundation of the V&A in 1852 was built with the aim of making works of art and design available to all, helping the education of all working people, and acting as an inspiration to the country's best designers.

The museum is vast and complex. Surprisingly, given the fashion for Gothic at the time, the buildings are in a North Italian Renaissance style, and Aston Webb's Main Entrance of 1899–1909 catches the eye. All very nice, but the highlights are the interiors of the Refreshment Rooms, the first museum in the world to have such a facility. The parts by William Morris are special, in a lavish neo-Elizabethan style.

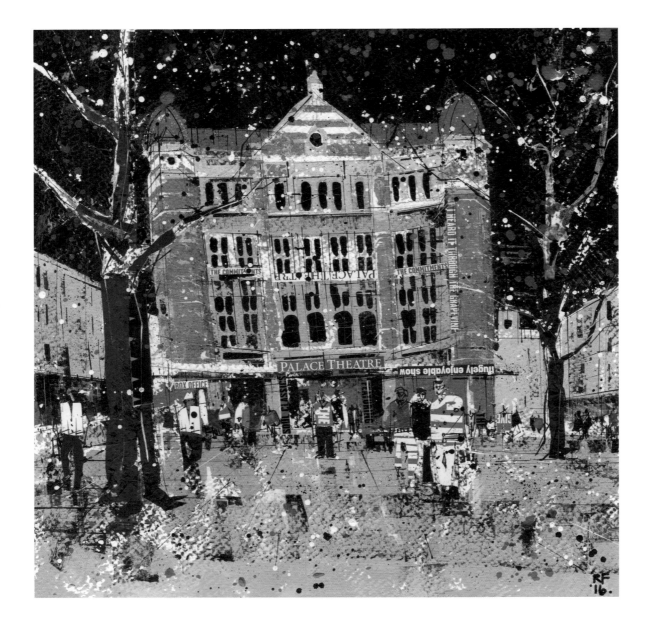

## Palace Theatre, Cambridge Circus

Many theatres occupy modest street frontages, relying on projecting canopies and signs to announce their presence. The Palace Theatre has a more favourable setting: its brick and stone banded facade with terracotta detail presides over Cambridge Circus in the heart of "theatreland". The slightly concave frontage, with corner octagonal bays topped with cupolas, gives a welcoming form.

It opened originally as the Royal English Opera House. This failed, but the venue is now a successful home for major musical productions.

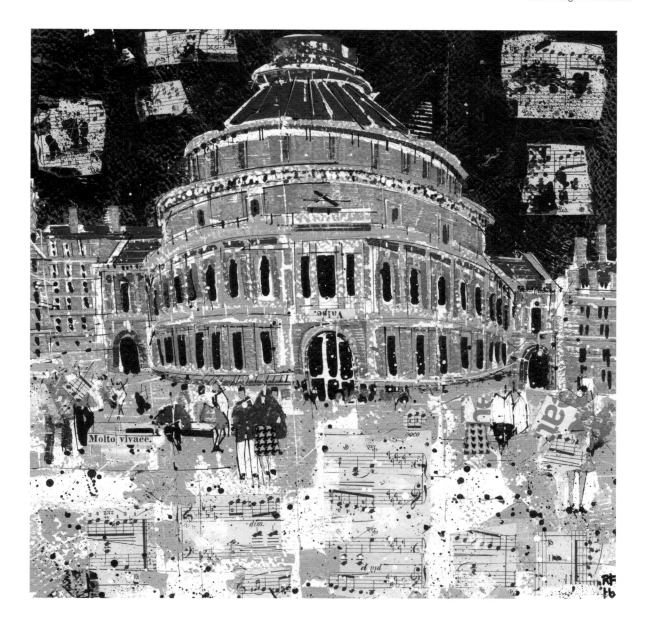

**Royal Albert Hall**

Inspired by ancient amphitheatres this vast concert hall can accommodate an audience of more than 5,000. Designed by a civil engineer, Francis Fowke, the Hall has elegant stone, terracotta and brick facades, in an Italian Renaissance style. The roof has iron girders supporting the glazed roof, all held in place by a giant ring beam encircling the elliptical roof. A mosaic frieze with figures and words runs around the perimeter.

Begun in 1867 the venue opened in 1871 and the flexible space has hosted a multitude of events from classical to rock concerts, circus performances and major tennis matches.

# LEISURE

With increased disposable income and more time for leisure, over the past two centuries there has been an ever-growing market for leisure pursuits. Once rooted in trade and a necessity for living, shopping has now become as much a leisure activity. This is a progression from the arcades first provided in the early nineteenth century with the simple aim of making shopping a more pleasant experience.

Meanwhile successful small shops have grown into national or international chains, and buildings have evolved and developed into grand department stores. These have become tourist destinations in their own right, with Harrods the most famous and iconic.

The street markets offer something different: casual and informal, the markets on Portobello Road, Brick Lane and Petticoat Lane offer colour, vitality and a rare bargain. However, again the focus has changed from providing for necessity to offering an experience.

Similarly, watching sport is now big business, and the sporting action is packaged into a much larger event. London's sporting arenas are of international significance, whether for the high quality of the architecture (Media Centre and Mound Stand, Lords; Wembley Stadium; Aquatics Centre at the Olympic Park) or the status of the sport they accommodate (tennis at Wimbledon).

Another global success is the British film industry. West End cinemas originated more than a century ago, providing comfortable surroundings. The focal point for this is Leicester Square, the host to great film opening nights, press shows and premieres, with the dark, handsome Odeon on the eastern side of the Square, the star venue.

In bygone times Londoners relied on simpler pleasures to fill their limited leisure time. Alehouses, coaching inns and taverns provided a social focus, with galleried inns offering more entertainment by overlooking an arena used for cockfighting and plays. As the coaching inns declined purpose-built public houses and gin palaces emerged, and the Victorians embellished the interiors with gas lighting, flamboyant decoration and large plate glass windows. The pub became an important networking and business environment, notably in Fleet Street where journalists could swap stories.

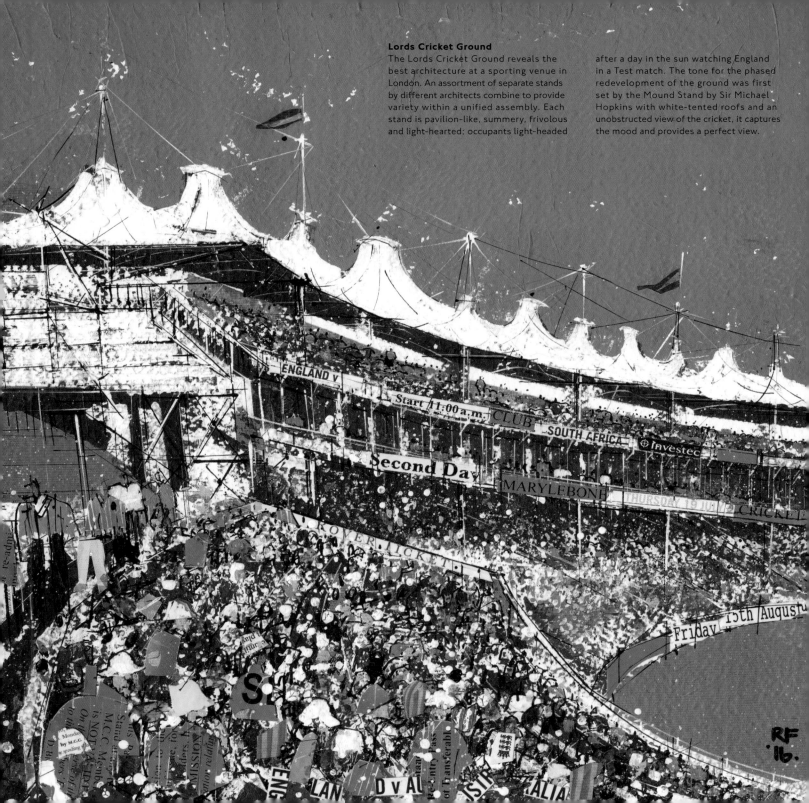

**Lords Cricket Ground**

The Lords Cricket Ground reveals the best architecture at a sporting venue in London. An assortment of separate stands by different architects combine to provide variety within a unified assembly. Each stand is pavilion-like, summery, frivolous and light-hearted; occupants light-headed after a day in the sun watching England in a Test match. The tone for the phased redevelopment of the ground was first set by the Mound Stand by Sir Michael Hopkins with white-tented roofs and an unobstructed view of the cricket, it captures the mood and provides a perfect view.

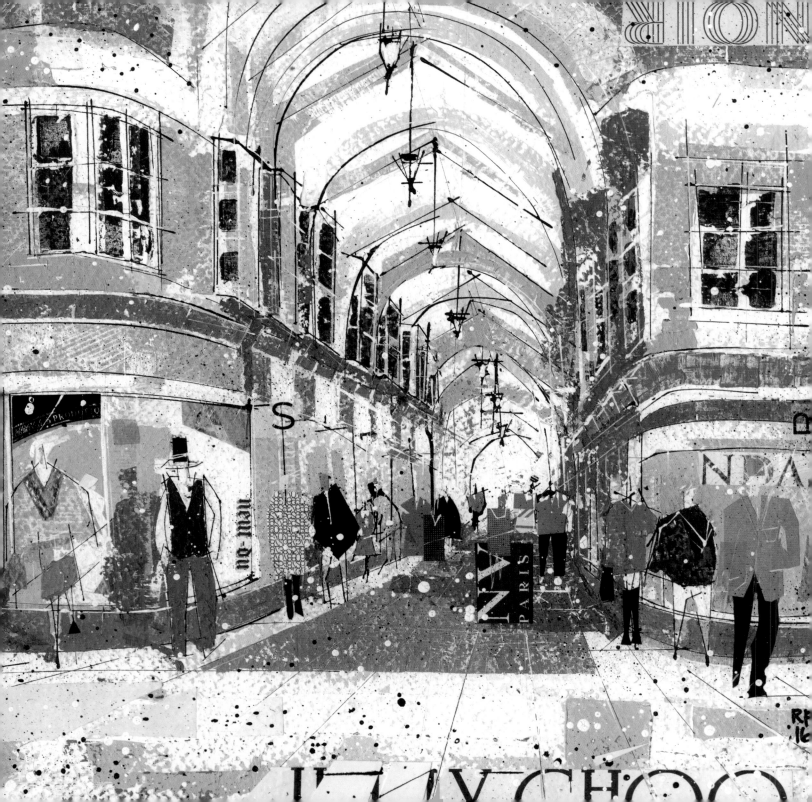

## Burlington Arcade

Built in 1818–1819 by Lord George Cavendish, owner of the adjoining Burlington House, this is the longest (178 metres) and best-known of London's shopping arcades.

The precedent had been set by the first covered shopping street, the Royal Opera Arcade by John Nash, inspired by Parisian models. Others followed, such as the elegant Royal Arcade, connecting Old Bond Street to Albemarle Street. The arcades offered shelter and a cleaner, quieter and safer environment than the surrounding streets.

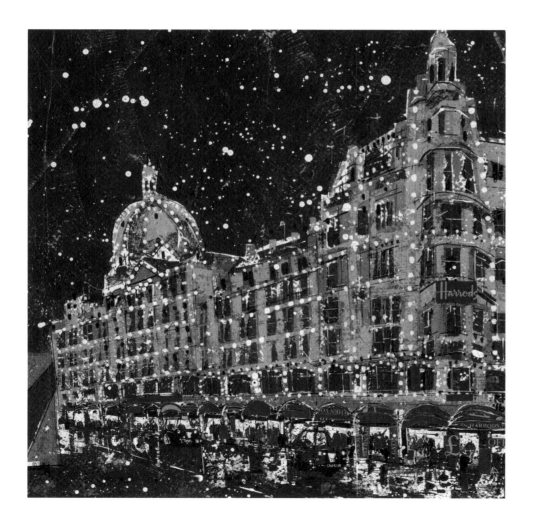

## Harrods

Master branding puts Harrods at the pinnacle of department stores, the air of exclusivity enhanced by its location in posh Knightsbridge and at night its facade, lit by 12,000 twinkly lights, taking on a magical quality.

The story is remarkable: in 1853 Charles Henry Harrod moved his fruit and vegetable shop from the East End of London to Brompton Road. With his son the business flourished and expanded, now covering a site of several acres. The story of the buildings has been one of constant change and development, including innovations such as the first shop to have escalators.

The main pink terracotta frontage is the iconic image, with two storeys of display windows with distinctive green awnings and shallow window heads, four storeys above with attics at the corners, and the central octagonal dome, cupolas, dormers and chimney providing the final flamboyant flourishes.

**Odeon Cinema, Leicester Square**

The scene of red carpets, film superstars, flash photos and film premieres, Leicester Square is the centre of London's great cinemas. The stark elegant Modernism of the Odeon, built in the 1930s, is the dominant form, in polished black granite. It is the largest in the country, holding 1,683 film-lovers in stalls and circle seating.

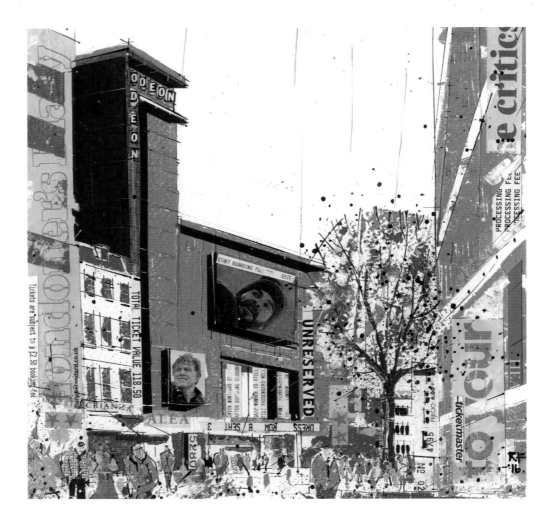

**The George, Southwark**

The only galleried inn that survives in London, a warren of timber panelled internal rooms and a series of bars create intimate spaces conducive to drinking and merriment. The long linear form defines a narrow courtyard, typical of the many alleyways that once ran at right angles to Borough High Street.

At the west end there are two levels of galleries (first and second floors), supported on cantilevered beams and timber columns. The eastern section is brick. The original inn was here in the sixteenth century and probably earlier, with the current buildings dating back to the seventeenth century. Mentioned in Charles Dickens' *Little Dorrit*, The George has been owned by the National Trust since 1937.

# PLACE

London embodies freedom. It is a relaxed collection of places, informally juxtaposed. There is little formal planning or grand boulevards in the style of Haussmann in Paris, or as seen in Barcelona, Berlin and other great cities. The nearest London gets to such grand gestures is around Westminster and Whitehall: Parliament Square, Trafalgar Square and the space in front of Buckingham Palace house the state's great occasions: impromptu and formal; solemn and joyous. Just as important to the ceremonies and layout are the connecting streets: The Mall, Whitehall and Birdcage Walk.

The City, by contrast, occupies the area of London's original settlement, and its origins and organic development are reflected in the layout of the streets. It is a district that lacks a heart, and a hierarchy: it is a complex web of narrow roads and alleyways, defined by buildings. A much-needed public space would have been provided by Mies van der Rohe's proposed office tower and public square, had his replacement for 1 Poultry been granted planning permission in the 1980s.

When London expanded in the eighteenth century beyond its original walls, large developments of former private estates were undertaken with rectilinear arrangements of streets and formal squares: Portman, Manchester, Cavendish, Hanover, Berkeley and Grosvenor Squares, for example. Sometimes the squares fulfil a civic function but elsewhere they provide gardens, locked and private, exclusively for the local residents to use.

It is unusual to find large-scale urban planning in central London. Regent Street is an exception. As London expanded to the west and north, Marylebone Park Farm, which belonged to the Crown, was developed for high-class housing from 1811 using plans by John Nash, the Prince Regent's favourite architect. To link this development to Westminster (via Trafalgar Square) and to the Prince's own Carlton House on Pall Mall, Nash cut a new street through the existing urban fabric. As well as providing the new route, the effect was to separate Mayfair to the west from Soho to the east.

Piccadilly Circus lies on Nash's route, but is much altered. Nash's Quadrant curved Regent Street from a southerly direction to the east; it then turned at right angles to head southwards again, meeting Piccadilly at a distinct space or "circus", matching that further north, at Oxford Circus. However, some 70 years later, to improve traffic flows down Regent Street and across to Haymarket and Trafalgar Square (and also to accommodate in 1884–1885 the introduction of a new street, Shaftsbury Avenue), buildings to the east of Regent's Street were demolished, losing the definition of Nash's layout. The Metropolitan Board of Works had to resolve a tricky geometrical problem, which it did in a piecemeal way. The result is that Piccadilly Circus is now a rather misshapen and amorphous vortex of converging roads.

Places are given vibrancy by activity. People from all nations come to work and visit. This creates a cosmopolitan atmosphere, particularly in the summer when cafes and bars overflow onto the streets that teem with activity: a major change that I have witnessed in the 32 years I have worked there. Instead of being linear spaces cluttered by cars and with the primary function of allowing movement, streets have become places to be, spaces to stop and enjoy. One of the liveliest is Brick Lane, at the heart of the East End.

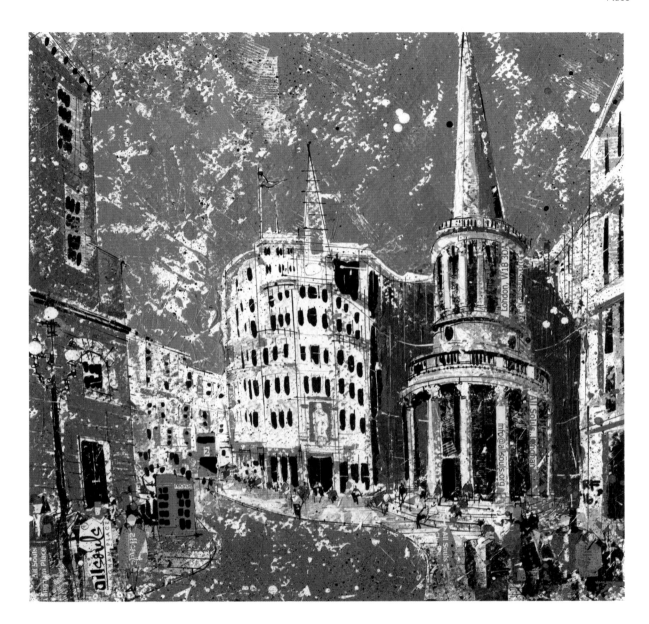

### All Soul's Church, Regent Street

Part of Nash's new Regent Street is this swiggle, needed to make an adjustment in the alignment of the street as it emerges northwards from Oxford Circus to engage with Portland Place.

This realignment coincides with All Soul's Church and its portico, and also the BBC building: the curving forms and views through the church portico make what might have been a difficult transition elegant and intriguing. Walking northwards from Oxford Circus, Portland Place gradually comes into view, the light and the curve of the street, enticing the pedestrian round the corner. If you have tricky geometry to solve, a circle, as here, often resolves everything.

## Trafalgar Square

Trafalgar Square is the setting for events of national importance: New Year celebrations, speeches by great leaders, carols, protests and riots. These occasions take place in a setting that is typically English: informal and slightly compromised. (It might have been very different: the original plan was to create two formal squares, either side of a Greek temple housing the Royal Academy.) A unifying element is provided on the north side, occupied entirely by William Wilkins' National Gallery.

To the north-east corner James Gibbs' St Martin-in-the-Fields dominates. This has a beautiful steeple and portico at its west end, lofty columns supporting a pediment and creating a lovely inside-outside space which for several years I used to pass through every day, walking to and from work. The best of the rest is Admiralty Arch, by Sir Aston Webb, and a relative newcomer (1911).

A lack of confidence has hindered recent history: first, in 1982, a design competition for the "Grand Buildings" site attracted 278 entries, only to end in the anti-climax of a solution that essentially retained the status quo. Then, following the Prince of Wales' infamous speech, describing the proposed National Gallery extension as a "monstrous carbuncle on the face of a much-loved and elegant friend" the winning scheme was replaced with an inoffensive but cautious postmodernist addition by Robert Venturi and Denise Scott Brown.

What Trafalgar Square really needs is a building that takes risks and excites, London's equivalent to what the Pompidou Centre by Piano and Rogers brought to Paris in the 1970s.

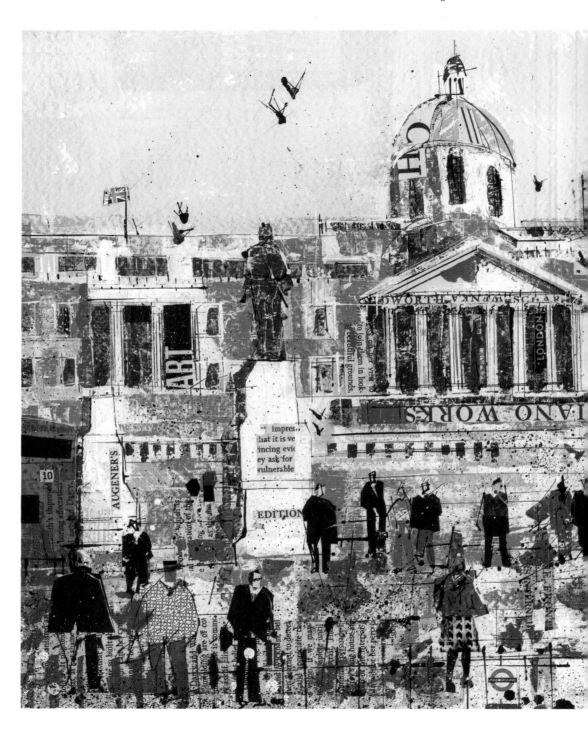

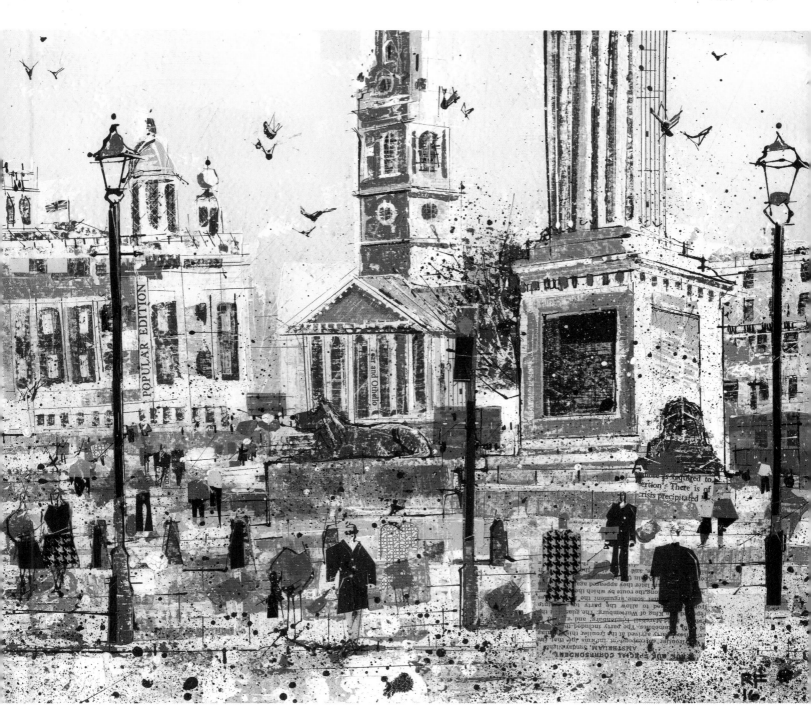

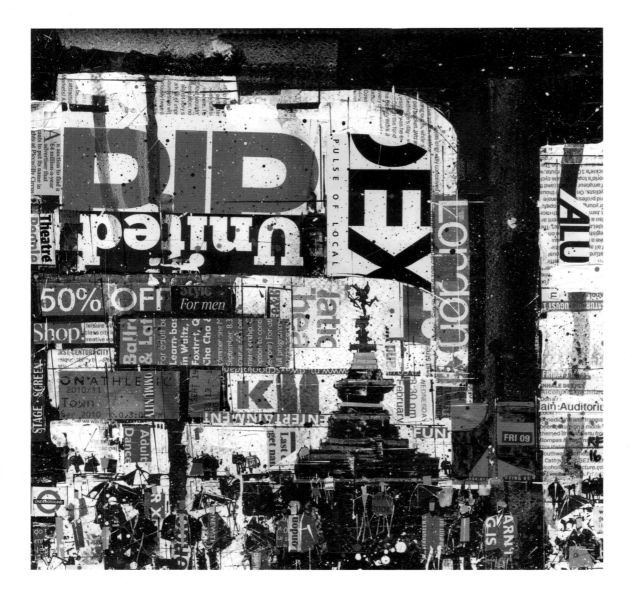

## Piccadilly Circus

Compounding the loss of the purity of Nash's original Regent Street layout was their replacement by buildings of poorer quality. In the 1890s illuminated advertising was beginning to appear on buildings and here, facing into the Circus, in 1904 a shop sign had appeared: "Mellin's Food". Advertising the wares of the host shop was one thing, but by 1910 generic signs had appeared, advertising products such as Bovril, Gordon's Gin, Guinness, Coca Cola and Schweppes.

Laws restricting advertising had been introduced in 1894 but these were designed to protect safety on roads rather than to control advertising. The building leases were silent on the matter, so the advertisements were here to stay, and are now seen by two million people who pass through every week.

Another icon is the slim, elegant statue of Eros, balanced on top of a high pedestal, silhouetted against the advertisements. Once in the centre of a frantic roundabout, in 1986 the roads were realigned and the statue moved southwards into an extended pavement in front of the Criterion restaurant.

**Parliament Square**

Surrounded by important buildings and inhabited by fine statues, such as the recognisable stooping pose of Churchill, the centre of Parliament Square is another urban space rendered unusable by being essentially an enormous traffic island. The best view is this one from the north side looking east, across the Square to Elizabeth Tower.

A clock tower was not in Charles Barry's original plan for rebuilding the Palace after the site was devastated by fire in 1834, but the 98-metre high landmark was added in 1859 to the design of Augustus Welby Pugin. This neo-Gothic creation is famed for its 7-metre diameter four clock faces made of cast iron and opaque white glass, and the distinctive chime of its Great Bell, "Big Ben".

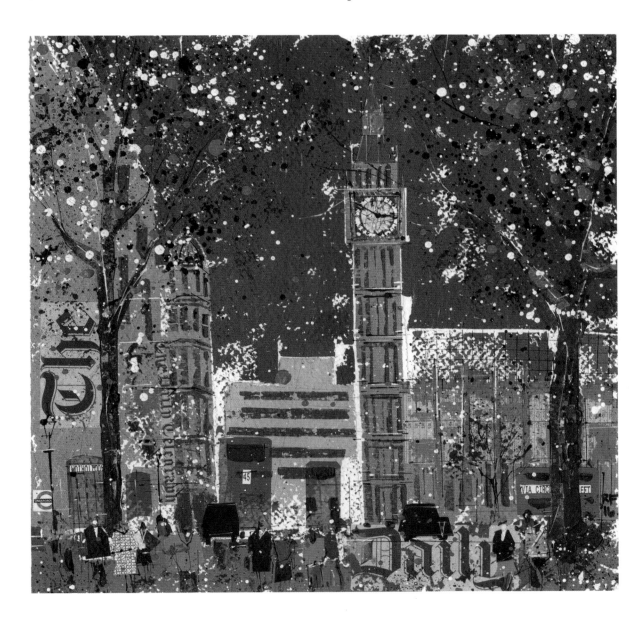

© 2016 Artifice books on architecture
and the author. All rights reserved.

Artifice books on architecture
10A Acton Street
London WC1X 9NG

t. +44 (0)207 713 5097
f. +44 (0)207 713 8682
sales@artificebooksonline.com
www.artificebooksonline.com

Cover: Westminster Abbey
Inside Cover: West End
Page 2: City Skyline
Opposite: Metropolitan Wharf
Inside Back Cover: The City

Designed by Sylvia Ugga
at Artifice books on architecture.

All opinions expressed within this
publication are those of the author
and not necessarily of the publisher.

British Library Cataloguing-in-Publication
Data. A CIP record for this book is available
from the British Library.

ISBN 978 1 908967 73 2

Artifice books on architecture is an
environmentally responsible company.
*Buildings of London* is printed on
sustainably sourced paper.

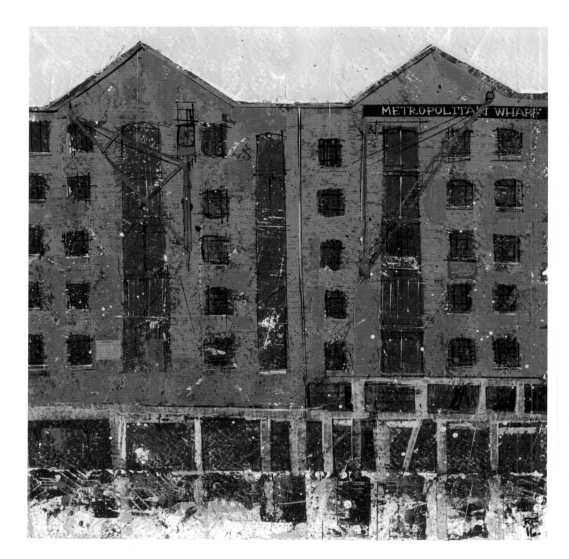